Designer/Author: Daniel Donnelly
Design Assistant: Shanti Parsons
Cover Design: Daniel Donnelly, Christian Memmott

First published in the United States of America by:
Rockport Publishers, Inc.
146 Granite Street
Rockport, Massachusetts 01966-1299
Telephone: (508) 546-9590
Fax: (508) 546-7141

Distributed to the book trade and art trade in the United States by:
North Light, an imprint of
F & W Publications
1507 Dana Avenue
Cincinnati, Ohio 45207
Telephone: (800) 289-0963

Other Distribution by:
Rockport Publishers
Rockport, Massachusetts 01966-1299

ISBN 1-56496-260-1

10 9 8 7 6 5 4 3 2 1

Manufactured in Hong Kong by Regent Publishing Services Limited

IN YOUR FACE

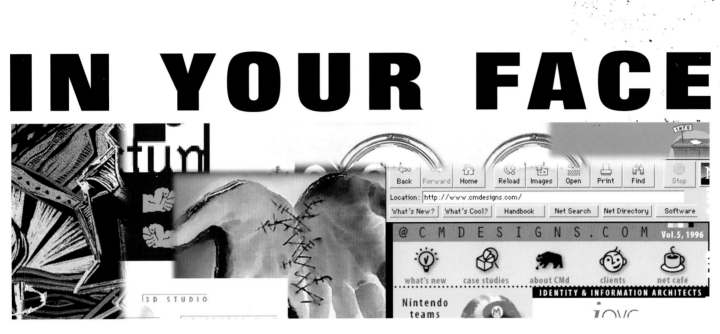

THE BEST OF INTERACTIVE INTERFACE DESIGN

ROCKPORT
PUBLISHERS

ROCKPORT PUBLISHERS, ROCKPORT, MASSACHUSETTS

Introduction

Acouple of decades ago the term "interface" barely existed in the sense we are using it today or, rather, how we should be using it. When they think about an interface, most people might think about buttons, dialogue boxes, or colors; it's not about these things. An interface is about hiding complexity from the user. It's about guiding a process, without cognitive understanding of what goes on beneath. Interface design is the art of enveloping the observer in an enticing, "try this" exploration with ever-new elements and designs as the tools to triumph in new territories.

•

My first program was a large paint application written in 1982, a couple of years before the Mac was released. It had the classic interface one could only call "inner faith," in which "option-control-click-u" would flip your brushes upside down while you twirled....Cool, but only for users who could figure it out. Soon, it became clear that computing power was only half of the art of creating software—getting it to be usable was the other half. It's like an old lady getting into a brand-new car: she turns the key, steps on the gas pedal and off she goes, without knowing (or caring) anything about how carburetors or transmissions work. And that's how it should be.

•

This book weaves a pictorial trail through the lovely landscape of interface design, a long-overdue collection of graphical front-ends from CD-ROMs and floppy demos to actual software programs. The images in this book freeze moments in time when designers tested new approaches for the first time, a nice snapshot of the state-of-the-art.

•

Most of these designs were unthinkable ten years ago. Just a few years back, I battled with the first 24-bit interface designs, using 2-D and 3-D buttons on layers, smoothly casting shadows onto complex backgrounds. My first forays met with critical frowns. They often won diamonds and stars from the computer press, but were accompanied with the tired "highly non-standard" caveat.

•

For me, interface designs *must* push the edge of the envelope: that's what they are all about. I don't design to make it easy for journalists to get reviews in by their deadline. Usually, real users come to appreciate even the "quirky-at-first-glance" controllers and rarely see them as contrived. Nevertheless, there's an element of tongue-in-cheek humor in my designs (after all, this isn't brain surgery or accounting—it's fun with graphics, best not taken too seriously). I always try to do things that are *not* on anyone's radar, things not asked for by users waiting for the 2.0 upgrade. It's important to create these things before they are safe.

•

Funny enough, if one were to include a few examples from a scant twenty years ago, it would boggle the mind to see how much simpler both the times and the designs were. In an average *Time* magazine from 1979, you would find ads

that have nothing but some copy and one pink triangle, and nothing more. Today, no graphic designer could hand in something like that as finished artwork. Everything has textures, shadows and layers. The complexity increases with no signs of stopping, as one can see throughout the pages of *In Your Face*.

•

The next step in complexity will include moving elements, halos and lights, in real 3-D scenes. Now these elements are pre-rendered; soon you truly will have full immersion into these new worlds. The next version of this book could be published on thin LCD pages with a few million (or billion) animated elements.

•

But it's not merely a wild and complex 3-D smell-o-rama that makes a good interface compelling. The pendulum swings back and forth—sometimes simplicity is called for. You can find extreme visual feasts for the MTV-short-attention-span-Generation-Xers right next to spare, terse, monochromatic designs. Both can succeed.

•

Often, the outermost shell of the interface could be—and ultimately, will be—changeable by individual users to suit their tastes. The outer shell isn't where the bulk of the design work lies. The shapes and colors of the buttons and knobs can take on any number of styles, but the task of the good designer is to deal with the underlying engines, or, in other cases, the vast boxes full of content requiring navigation. The interface designer takes the user by the hand and gently nudges him or her to experience their potential through the interface and its underlying content.

•

For me, this has become a true marriage where I spend half my time on deep mathematics finding and pushing the limits and the other half on hiding heavy, engine-level stuff so even children can have fun with it. This is not a metaphor, but a design principle. I often design for kids; it's probably true that if an interface and content are manageable for 12-year-olds, then the mythical "average executive" can figure it out as well.

•

I do not agree with those who say "everything has already been done." I cling to the hope that we have not seen anything yet. We are still dabbling with the smallest of baby steps—if now we stand on the shoulders of past giants, let's make sure that, in the future, we don't stand on the kneecaps of midgets. Designers need to know the current state of the art, and *In Your Face* is the definitive collection.

•

Surely, it's a snapshot of the time where we happen to find ourselves. And among all the factors coming into play we find ourselves with historical accidents like Windows 95, System 7, UNIX and others, many of which will cause our grandchildren to roll on the floor in hysterics.... This is the new Renaissance, and these are the golden days.

•

This book really should be a standard work in the shelves of software engineers, and CD-ROM and Web designers. It only takes one new angle, one new inspiration, or a bit of a nudge from one of the many examples here...and it will pay for itself many times over.

•

I hope you enjoy these forays into the world of multimedia design and realize that each interface represents the work and sweat of a lot of people. These things do not come easy at times. They require gallons of perspiration, often accompanied by perplexity and percolating paranoia. Sometimes acute lack of sleep and staring at a lot of phosphor are also part of the package. It's 3 percent luck, too.

Kai Krause
MetaTools Inc.

CD-ROM

CD-ROM art direction is a whole new field where the objective is not creating a static page, a TV spot, or a radio campaign—the objective is to create an experience, a user-controlled journey that the art director helps to make satisfying and worthwhile. Not only does the art director of interactive software have to master typography, image manipulation, and layout, but also animation, sound, video, and interface design, each a field of its own.

•

Some say it's easy for print art directors to cross over to CD-ROM design; others say television graphic art direction is less of a transition. I believe that CD-ROM art direction is an entirely new discipline. Unlike print production, CD-ROM production relies heavily on the collaborative effort of talented individuals, similar to a Hollywood production. The art director is the *auteur* of the overall concept, look, feel, style and sound of the project. CD interface design is influenced by the music, motion picture, design, and computer graphics industries.

•

Some of the most successful interface designs are invisible, seamlessly welding themselves to the user's experience. The user becomes so comfortable with the navigational device that it becomes an extension of the user's sense—if this is your goal, then you have succeeded. These interfaces let you explore in a manner appropriate for the content and develop a multi-sensory language unique to the subject; what works for a CD-ROM game will not necessarily work for a CD-ROM catalog. The interface architecture may be complex, but it must be structured so that it is invisible or intuitively understood by the user. This requires that the CD-ROM art director have an intimate relationship not only with multimedia content, but also with multimedia users.

•

Rectangular buttons are dead. When interactive CD-ROMs first became popular, they were designed and created mostly by programmers who had no design training, and thus produced functional—but unattractive—designs. Now that the threshold of

required technical knowledge has been lowered, more designers are creating interactive content. This influx of young creative talent results in richer, more complex environments in which to journey. Some fine examples are illustrated throughout this book.

•

Interface style plays an important role in defining mood and environment for the user. No rules dictate that all interface design needs to be clean, simple, and to the point, although this approach works well with a majority of content. It is wise to remember that there are times when an interface with an alternative or difficult-to-comprehend graphic style brings a user closer to a particular content and mood.

•

Many CD-ROM projects lack attention to typographical detail, because interfaces often are designed with only a printed image in mind. Reading type on a computer screen is difficult in comparison to a printed piece, so type treatment is critical to an onscreen environment. Type problems demand creative solutions. For example, I try to use voice-over in heavy copy areas to allow the user to concentrate on the visual.

•

Up until a short while ago, the CD-ROM experience was a self-contained universe. Now with the ubiquitous, 24-hour World Wide Web, the option of merging two mediums is available. Programming allows a CD to connect to the Web to unlock graphics or update information. CDs are no longer a single-experience medium. Content wizards mix media by developing programs to link them. The implications for content development are enormous as technology moves forward, and as content from CD-ROM, the Internet, film and television, and presently unimagined sources are accessed and blended.

David J. Link
Associate Creative Director
Modem Media

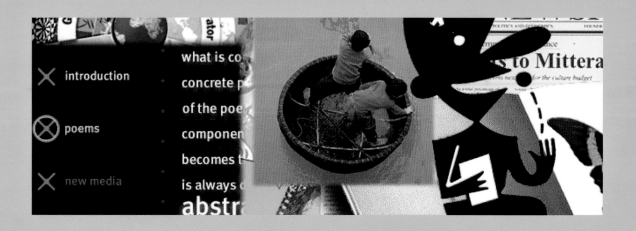

DIGITAL EXHIBITION

Passage to Vietnam from Rick Smolan (who also authored *From Alice to Ocean*) is perhaps the most intelligent and beautifully designed CD-ROM. A culmination of eighteen months of work by seventy photographers, this award-winning CD-ROM shows an intimate portrait of the people, culture and country of contemporary Vietnam in its more than four hundred photographs. Accompanying the photographs are video sessions with photographers; video and audio clips that explain how and why certain photos were taken; and visits to virtual galleries that acquaint you in detail with four photographers' work.

The interface makes use of ad•hoc interactive's "Quebe," a cube-shaped icon that rotates with mouse clicks, which resides in the lower right corner of the screen. Each side has a function that carries the user to different topics, a map, the help screen, or more tools.

During the exploration of *Passage to Vietnam*, the Quebe opens to reveal different items such as a formal invitation for the user to enter a virtual gallery of photographs. At one point Rick Smolan, the project's creator, appears from the top of the Quebe to explain the navigational aspects of the Quebe and the CD-ROM s interface.

In all aspects of the interface, the designers find ways to capture the user's attention, from beautiful photography to a clever video sequence of the publisher walking out onto a precarious monkey bridge to introduce the next topic.

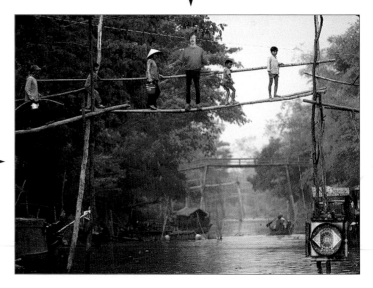

DREAMS OF A GENTLE LAND
by Pico Iyer

Like most tropical countries, Vietnam gets up with the light, and one of the greatest pleasures you can find there is to go outside at six in the morning and see the whole town out stretching its limbs, playing badminton or soccer in the streets, ghosting its way through *tai chi* motions.

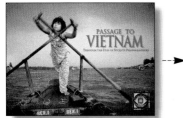

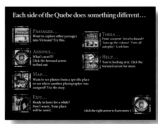

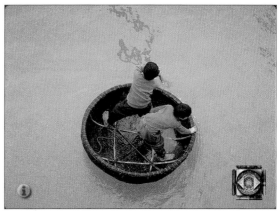

Project: **Passage to Vietnam**
Client: **Against All Odds Productions**
Design Firm: **ad•hoc Interactive Inc.**
Designers: **Aaron Singer, Megan Wheeler**
Illustrator: **Megan Wheeler**
Photographers: **70 international photographers**
Programmer: **Shawn McKee**
Authoring Program: **Macromedia Director**
Platform: **Mac/Windows/Windows 95**

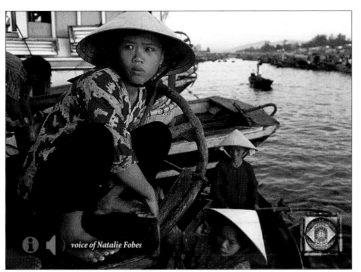

voice of Natalie Fobes

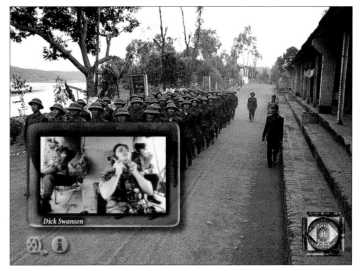

Dick Swanson

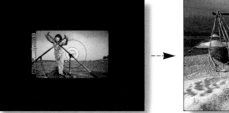

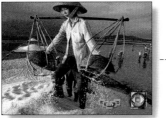

EDUCATIONAL/REFERENCE

The Nine Month Miracle by A.D.A.M. Software helps the whole family discover the secrets of life from conception to birth in an experiential manner, not in a reference manner.

Users select one of three modes to explore: anatomical study, the Family Album, and a Child's View of Pregnancy. The anatomy module, a subset of A.D.A.M.'s medical student anatomy modules, allows users to see different layers of organs, muscle and bone and also allows users to view front and rear views. The strengths of this project rest with its comprehensive indexing of anatomy; its access to a large quantity of material; and its accommodation of a variety of audiences and situations: users can change the figure's gender, race or level of modesty to suit their own preferences. Fig leaves are an option, in consideration for parents who might use *Nine Month Miracle* to explain the addition of a new brother or sister in the family.

The Family Album follows a young couple, Eve and Adam, month by month, from conception through birth. With the help of their obstetrician, Dr. Richards, and a device called the E.V.U. 3000 (Eve's Virtual Uterus) Eve's pregnancy is explained from the inside out, with dramatic in-body photographs and cutaways that diagram the fetus' development. Navigation through the album is accomplished through clicking on baby icons at the bottom of the pages.

The Child's View of Pregnancy contains a well-crafted explanation for children, with a variety of games to help teach about genetics, gender determination, and other topics.

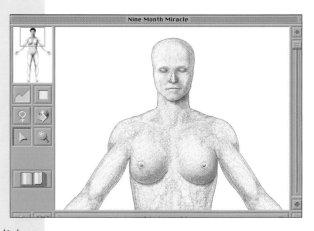

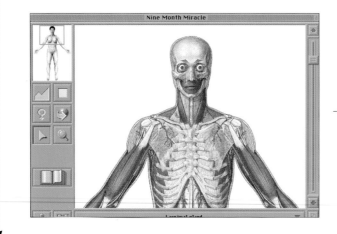

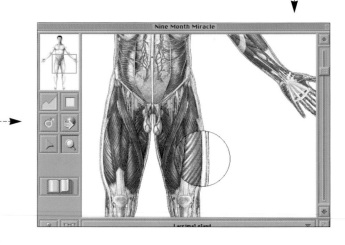

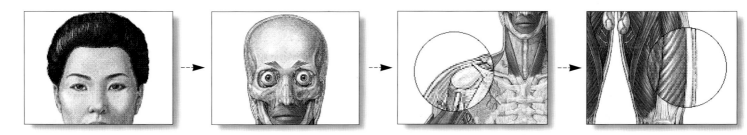

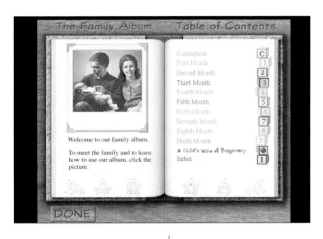

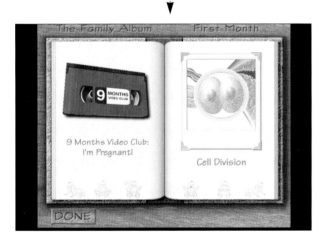

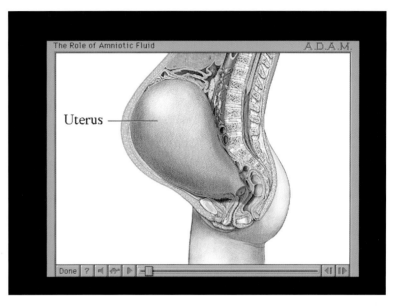

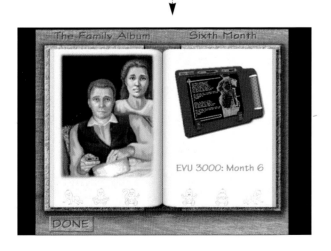

Project: *Nine Month Miracle*
Design Firm: **A.D.A.M. Software**
Designers: **Internal Production Group**
Authoring Program: **C, C++, Macromedia Director**
Platform: **Mac/Windows**

 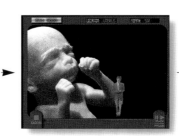 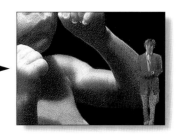

DIGITAL EXHIBITION

A Passion for Art's introduction sets the CD-ROM's theme: a beautiful collage of photos, illustrations and art set to music and voiceover create a feeling of the 1920s and '30s when the Barnes Art Museum first opened to the public. It closed not long after.

The interface enhances the illusion of entering and exploring an art museum. Buttons are simple and effective, labeled for easy access and navigation. At all points in the interface, the designers have worked to help users identify what they are looking at, and where they are in the museum.

The designers created different ways to view paintings in the museum: the "Paintings" button allows artwork to be viewed sequentially at full screen size; the "Gallery" button allows for virtual navigation of the museum, letting users walk through rooms and click on paintings hanging on the wall; a horizontally scrolling "Timeline" button presents the paintings in chronological order along with other significant developments of the period; and an "Archive" button allows access to significant documents relating to each painting.

To maintain the experience of visiting a museum, the designers provide several tours through the museum. A timeline lets the user know how long the tour will be, and each tour gives an in-depth look at several pieces including an informative presentation about the Henri Matisse mural that hangs over the entry to the main exhibit hall.

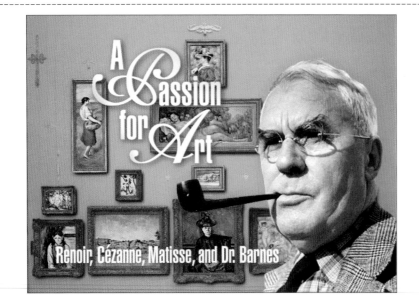

Project: *A Passion for Art: Renoir, Cézanne, Matisse, and Dr. Barnes*
Design Firm: **Corbis Publishing**
Creative Director: **Curtis G. Wong**
Interface Designer and Art Director: **Pei-Lin Nee**
Design Team: **(see Developer's Listing)**
Writers: **(see Developer's Listing)**
Platform: **Mac/MPC**

14

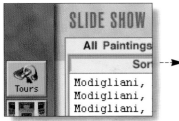

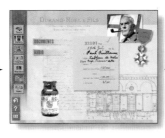

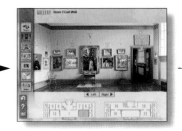

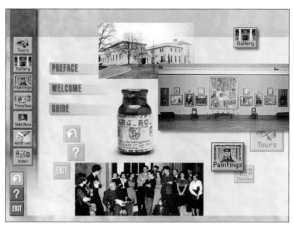

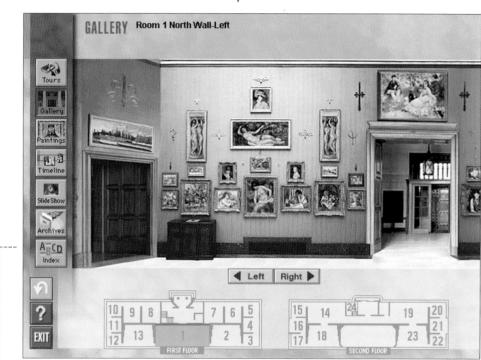

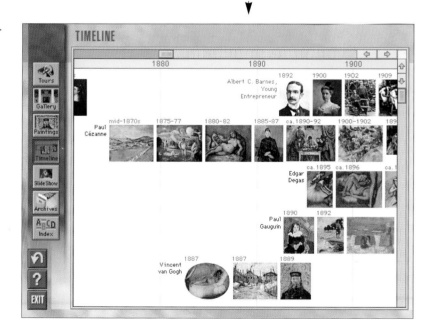

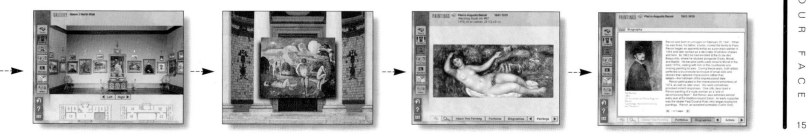

PROMOTIONAL PRESENTATION

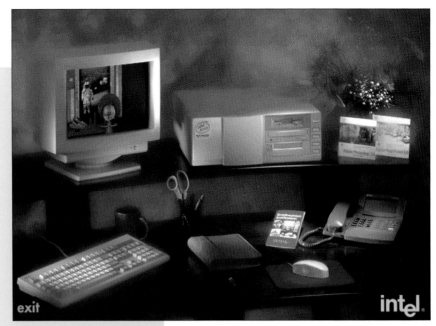

Making History with Pentium uses an interface based on the metaphor of the home and office desktop workstation. Certain objects on the desk such as the monitor, computer, keyboard, video phone, and organizer serve as buttons that display information when clicked. These active items are illuminated to distinguish them from non-active items such as the pencil holder, which appear in shadow. This simple interface projects what Intel sees as Pentium's worry-free, no-hassle reputation, immediately understandable by most users.

The organizer is an example of creative minimalism, where a simple pencil sketch of a photograph transforms into a rotoscoped video presentation. Pencil sketches of video control buttons cleverly do the job of conventional buttons.

By providing no text cues except the "exit" button, this interface simulates a real workstation environment and encourages exploration of visual elements.

Project: *Making History with Pentium*
Client: **Intel Corporation**
Design Firm: **Lightspeed Interactive**
Designers: **Ian Atchison, Jeanine Panek**
Programmer: **Kevin Flores**
Writer: **Ira Ruskin**
Digital AV: **Shawn Nash**
Video: **Breene Kerr Productions**
Authoring Program: **Macromedia Director**
Platform: **Mac/Windows**

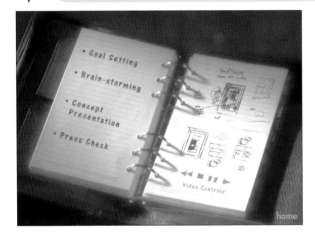

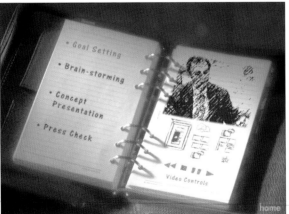

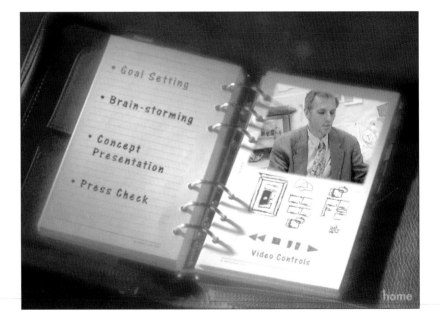

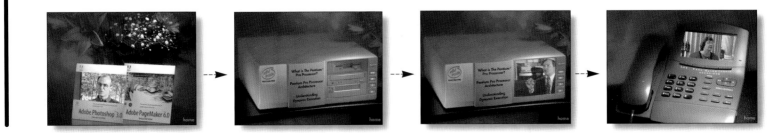

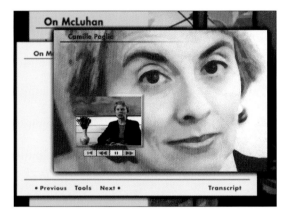

Understanding McLuhan presents a multi-faceted profile of Marshall McLuhan, the late Canadian media theorist, using his own words in text and video. Views on McLuhan by colleagues and critics round out an intelligent profile of a profoundly influential thinker. This piece accurately reflects the complexity of McLuhan's insight on the relationship between technology and information.

The navigation interface is characterized by layered presentation and data windows in a desktop format. As each layer is opened, the display's size and position is offset, allowing access to the layer below by clicking on it.

An elaborate toolbox is available to the user, allowing for detailed word or topic searches of both written works and also the video interviews which have been thoughtfully transcribed. The notebook function makes this CD-ROM a valuable research tool, as memorable passages can be collected for later review.

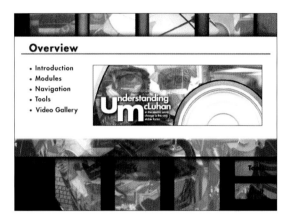

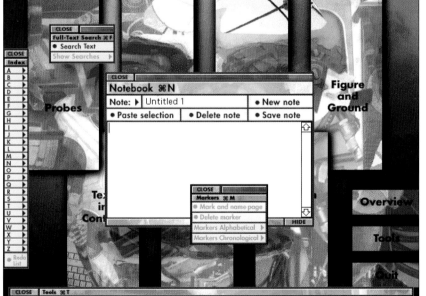

Project: *Understanding McLuhan*
Design Firm: **Southam Interactive**
Designers: **Dan Clark, Maxine Wright**
Illustrators: **Dan Clark, Maxine Wright**
Programmers: **Russ Montgomery, Dan Beer**
Photographer: **Mat McCarthy**
Authoring Program: **Macromedia Director**
Platform: **Mac/Windows**

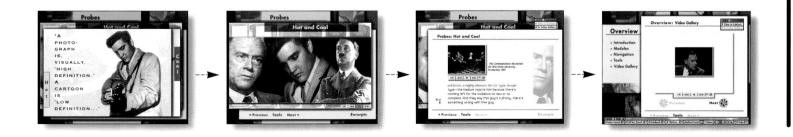

ADVENTURE GAME

Bad Mojo™, produced by Pulse Entertainment, is an example of a seamless navigational environment. The interface requires the user to interact with a clue-filled visual environment featuring a roach as its central character.

The user controls the action of the roach with four keyboard commands (left, right, forward and backward). As the roach scurries across hidden hotspots, different actions are set in motion. For example, crawling across an electrical cord turns on a vacuum; scuttling too near an apparently dead rat's mouth results in losing a roach-life (opposite page).

The designers have created a set of linear experiences for the user to follow by using obstacles—such as water, blood, and rat poison—to keep the user heading in the right direction. An added visual cue is the appearance of a "guide roach" that appears, shows which way to go, and then disappears.

Users begins their journey by exiting a drain that leads to the underside of a furnace, complete with animated, deadly flames. Users get an overview of the playing area by crawling to vantage points located throughout the 3-D world. The creative, gritty and sometimes disgusting illustrations are beautifully rendered, placing the user in a realistic roach-world.

Eerie background music and ambient sounds combine with video sequences to complete the sensation of traveling through the dark and dangerous world of cockroaches.

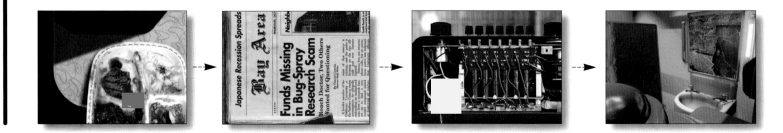

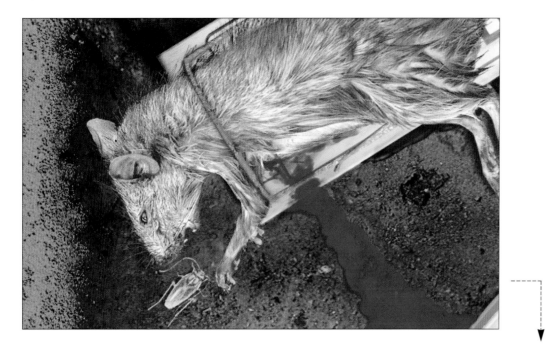

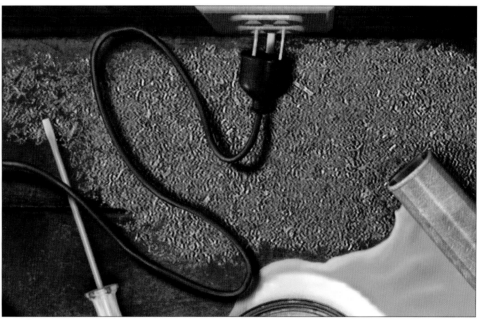

Project: *Bad Mojo*
Design Firm: **Pulse Entertainment Inc.**
Art Director: **Lawrence Chandler**
Art Director, Special Sequences: **Charles Rose**
3-D Technical Director: **Dan Meblin**
Programmers: **(see Developer's Listing)**
Audio Engineer: **Bill Preder**
Authoring Program: **Proprietary**
Platform: **Windows**

ADVENTURE GAME

Buried in Time, with digital readouts glowing red and green and metal surfaces rendered in detail, breaks away from the currently popular interface—a *Myst* clone that usually includes invisible buttons—and uses a navigational arrow button that floats to the right-hand side of the screen. This button with its five arrows is the main navigational tool used throughout the game.

A time-travel game, *Buried in Time* allows the user to jump from one era to the next while collecting clues in each time period. The user wears a jumpsuit called the "deep time unit," and explores the game by walking through rendered 3-D scenes.

The player's view through the jumpsuit helmet provides a unique picture-box perspective with which to navigate this game of mystery and intrigue. Most tools (such as biochips for all occasions and a readout at the top of the screen that gives explanations of happenings and tools) needed to play are situated inside the jumpsuit interface. Clues are hidden in different time periods and interesting places such as Leonardo da Vinci's studio.

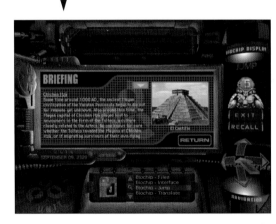

Project: ***Buried in Time***
Design Firm: **Presto Studios, Inc.**
Designers: **Phil Saunders, E.J. Dixon, Frank Vitale**
Illustrators: **Victor Navone, Shadi Almassizadeh, Eric Fernandes, Eric Hook**
Programmers: **Greg Uhler, David Black**
Authoring Program: **Macromedia Director, C++**
Platform: **Mac/Windows**

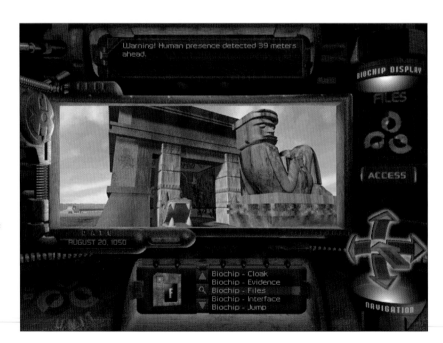

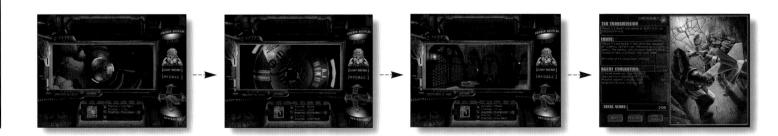

Project: **Digital Dexterity**
Client: **Marcolina Design Inc.**
Design Firm: **Marcolina Design**
Designers: **Dan Marcolina, Matt Peacock,**
Quinn Richardson, Mike Lingle
3-D Animator: **Matt Peacock**
Voiceover: **Dan Marcolina**
Programmers: **Quinn Richardson, Mike Lingle**
Authoring Program: **Macromedia Director**
Platform: **Mac**

Marcolina Design's portfolio stands out with its use of a beautifully rendered collage for its contents screen. The piece is rich with interactive opportunities, and rewards the user's curiosity with beauty, whimsy and technical excellence.

Marcolina uses pieces of the illustration—such as the fingers—as buttons that provide either fun tangents or navigational function. Each finger, as well as the moth, takes the user to a different video sequence or an interesting screen effect. Three buttons on the lower-right side of the interface are rollovers that animate when clicked on, and reveal video sequences or even more buttons to explore.

Along with interesting buttons and video, the design includes unique touches: video displayed on the awards cup; the graphics window stretches for viewing portfolio pieces; and voiceovers that play only when the mouse button is held down over the mouth icon.

DIGITAL PRESS KIT

Musician Cleto Escobedo's ethnic background was kept in mind when the designers created both Spanish and English interfaces to navigate this interactive publicity presentation.

To convey the feeling of music, the designers integrate buttons, text and video into music-oriented elements. Saxophone keys on the main menu screen are rollover hotspots that, when clicked, sound a musical note and then take the user to another area of the interactive. Text is set on the right-hand page of a songbook, and a video interview is artfully integrated into a glass of wine. One of Cleto's music videos plays in a rendered 3-D window. Both videos can be viewed in either English or Spanish.

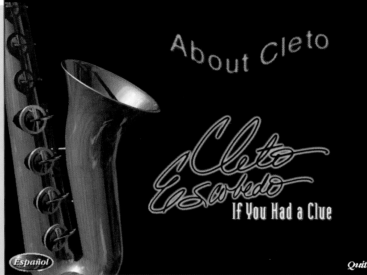

Project: **Cleto Escobedo Interactive Press Kit**
Client: **Virgin Records**
Design Firm: **Tuesday Group Inc.**
Designer: **Richard Parr**
Illustrators: **Steven Mausolf, Nancy Brindley**
Programmer: **Scott Seward**
Authoring Program: **Macromedia Director**
Platform: **Mac/Windows hybrid**

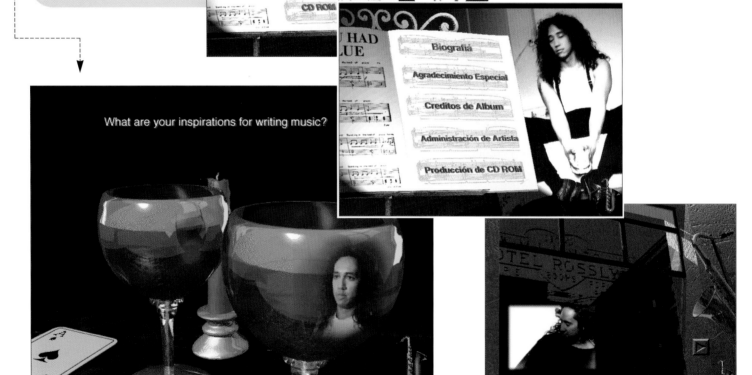

Project: **A Postcard from Hollywood**
Client: **Ginza Graphic Gallery**
Design Firm: **Rhythm & Hues Studios Inc.**
Executive Producer: **John Hughes**
Designers: **Tex Kadonaga, Miles Lightwood**
Director/Illustrator: **Tex Kadonaga**
Programmer: **Miles Lightwood**
Producer: **Jean Tom**
Composer/Sound Designer: **Jay Redd**
Authoring Program: **Macromedia Director**
Platform: **Mac**

DIGITAL PORTFOLIO

Rhythm & Hues Studios' portfolio lives up to its reputation for producing some of the industry's most creative animations and visual effects. Designed as a catalog of selected works from the firm's 1995 Tokyo exhibition at Ginza Graphics Gallery, the portfolio contains video samples of award-winning pieces, demonstrations of computer graphics processes, and a look at the Rhythm & Hues team.

The opening background showcases one of the studio's most popular commercials—the Coca-Cola polar bear series—using initial pencil renderings for the design. Though the interface is basic in its structure and uses simple navigation and easily identified buttons, elements such as the four rotating contents buttons add a distinctive look and feel to the interface, as do the coloring and architectural design elements used on all of the background screens.

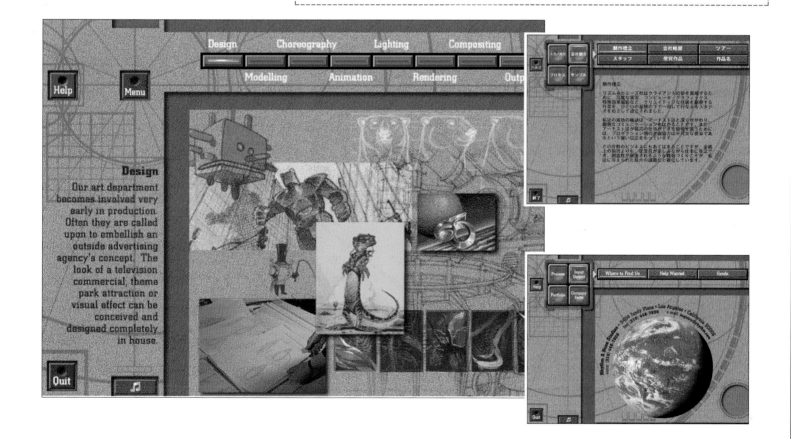

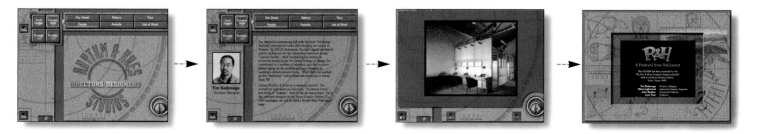

VISUAL POETRY

Understanding Concrete Poetry explains, interprets and reconfigures poetry. The core idea of this art form and academic project is this: the visual form of the poem is an essential part of its interpretation.

The project transforms typography from its traditional, static form into a dynamic form, using moving, pulsing text that highlights to show when a link is attached to it. This opens users to a visual interpretation of the poetry form with audio components.

The quiet, understated interface is secondary to the CD-ROM content, leaving space for users to begin their exploration. The designer develops a graphic language that parallels semantic meaning by breaking up a flat, two-dimensional image with blurred letterforms, and also breaking it into functional quadrants, which set up a confluence of interface and content. An advantage of this approach to interface design is easy access, which allows full focus on the content.

Project: *Understanding Concrete Poetry*
Client: **Art Center College of Design**
Design Firm: **Thomas Müller**
Designer: **Thomas Müller**
Authoring Program: **Macromedia Director**
Platform: **Mac**

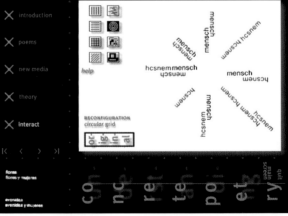

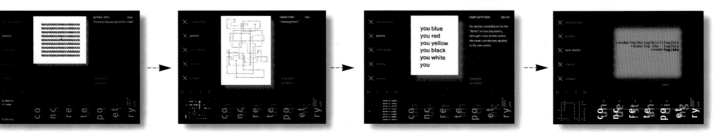

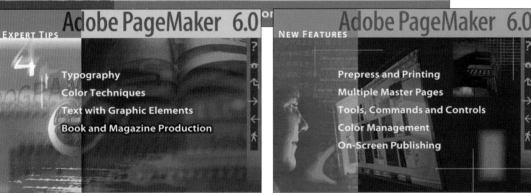

Welcome to PageMaker gives an overview of the page-layout software, and promotes the Adobe products line.

Sensibility characterizes this interface. Its form suits its function by combining easily readable text treatments, professional video production, and a pleasing, gridded layout to promote a tool that makes the publishing process more efficient.

The presentation opens with an animated collage featuring printed pieces created with PageMaker, then fades to the main contents screen. Memorable touches appear throughout the interface: instead of using conventional button-clicking sounds, pleasant musical tones sound when the cursor rolls over the text-based buttons; artfully executed backgrounds used on the main sections of the interface make for impressive presentation.

Project: *Welcome to Pagemaker*
Client: **Adobe Systems Inc.**
Design Firm: **Adobe Creative Services**
Art Director: **Thom Feild**
Designers: **Scott Chesnut, Kathleen Koeneman**
Programmer: **Sumo Corporation**
Sound Director: **BC Smith, Cinevox**
Authoring Program: **Macromedia Director**
Platform: **Mac/Windows**

VIRTUAL TOUR

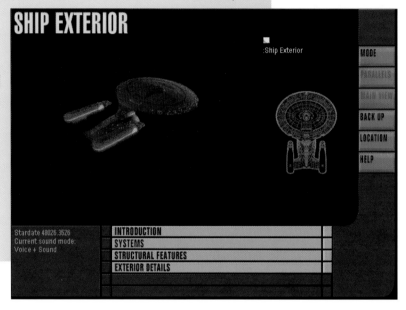

Star Trek: TNG™ (The Next Generation) Interactive Technical Manual appeals to Star Trek fans, but even non-fans will appreciate the work involved in putting together such an in-depth look at one of the century's most famous media creations, the starship Enterprise.

The interface for Star Trek: TNG™ is designed for easy exploration of the inside and outside of the entire ship. The "location" button allows exploration of a number of onboard areas such as the sick bay, shuttle bay or transporter room. From the outside of the ship, the user can zoom in on a section, look through a window into the ship, and enter that area.

The interface offers two ways to navigate from section to section inside the ship: a "jump" button takes the user directly to the chosen area; a "transit" button uses animation to move into a turbolift and onto another level.

Of all the elements the interface offers for navigation, the most intriguing and engaging is the QuickTime VR, which allows the user to enter a room and navigate through a QuickTime movie in a 360° circle. The QuickTime movie also incorporates hot spots that link to objects centered around the room. This lets the user look into dresser drawers, or view other items of interest found within the area of the movie.

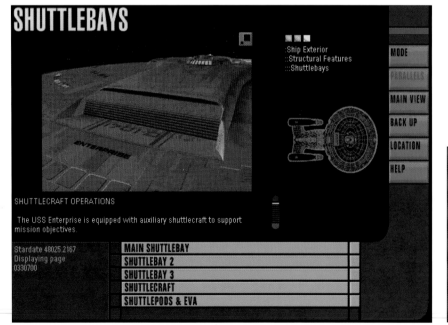

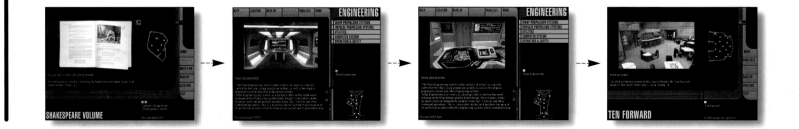

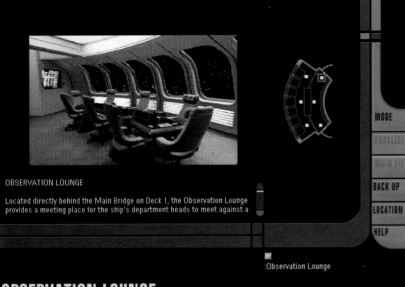

OBSERVATION LOUNGE

Located directly behind the Main Bridge on Deck 1, the Observation Lounge provides a meeting place for the ship's department heads to meet against a

:Observation Lounge

OBSERVATION LOUNGE

Displaying page 0600000

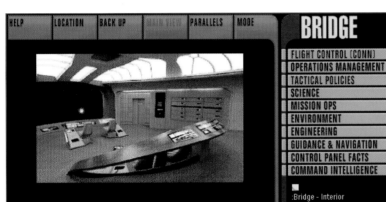

HELP LOCATION BACK UP MAIN VIEW PARALLELS MODE

BRIDGE

- FLIGHT CONTROL (CONN)
- OPERATIONS MANAGEMENT
- TACTICAL POLICIES
- SCIENCE
- MISSION OPS
- ENVIRONMENT
- ENGINEERING
- GUIDANCE & NAVIGATION
- CONTROL PANEL FACTS
- COMMAND INTELLIGENCE

:Bridge - Interior

MAIN BRIDGE

The central area of the Main Bridge provides seating and information displays for the commander and two other officers. Directly fore of the command area are the Operations Manager and the Flight Control Officer, both of whom face the main viewer.

Directly aft of the command area is an elevated platform on which is located the tactical control station. Also located on the platform are five workstations, nominally configured as Science I, Science II, Mission Operations (Ops), Environment, and Engineering.

Stardate 48025.5368

Project: **Star Trek: TNG™ Interactive Technical Manual**
Client: **Simon & Schuster Interactive**
Design Firm: **Imergy**
Designers: **Michael Okuda, Denise Okuda**
Art Director: **Debra Leeds Schwartz**
Art: **Jessica Perry**
Lead Production/VR Management: **Marshall Lefferts**
Programmers: **Peter Mackey, Adam Neaman**
Photographers: **Bill Dow, James Castle**
Animators/Lingo: **(see Developer's listing)**
Authoring Program: **Macromedia Director**
Platform: **Mac/Windows**

HELP LOCATION BACK UP MAIN VIEW PARALLELS MODE

BRIDGE

- FLIGHT CONTROL (CONN)
- OPERATIONS MANAGEMENT
- TACTICAL POLICIES
- SCIENCE
- MISSION OPS
- ENVIRONMENT
- ENGINEERING
- GUIDANCE & NAVIGATION
- CONTROL PANEL FACTS
- COMMAND INTELLIGENCE

:Bridge - Interior

MAIN BRIDGE

The central area of the Main Bridge provides seating and information displays for the commander and two other officers. Directly fore of the command area are the Operations Manager and the Flight Control Officer, both of whom face the main viewer.

Directly aft of the command area is an elevated platform on which is located the tactical control station. Also located on the platform are five workstations, nominally configured as Science I, Science II, Mission Operations (Ops), Environment, and Engineering.

Stardate 48025.5368

HELP LOCATION BACK UP MAIN VIEW PARALLELS MODE

FLIGHT CONTROL

- BEARINGS
- HEADINGS
- DUTIES
- FLIGHT INFORMATION INPUT

:Bridge - Interior
:Flight Control

FLIGHT CONTROL (CONN)

The Flight Control console, often referred to as Conn, is responsible for the actual piloting and navigation of the spacecraft. Although these are heavily automated functions, their criticality demands a human officer to oversee these operations at all times. The Flight Control Officer (also referred to as Conn) receives instructions directly from the Commanding Officer.

Manual flight operations. The actual execution of flight instructions is generally left to computer control, but Conn has the option of exercising manual control over helm and navigational functions. In full manual mode,

Displaying page 0420100

HELP LOCATION BACK UP MAIN VIEW PARALLELS MODE

BRIDGE

- FLIGHT CONTROL (CONN)
- OPERATIONS MANAGEMENT
- TACTICAL POLICIES
- SCIENCE
- MISSION OPS
- ENVIRONMENT
- ENGINEERING
- GUIDANCE & NAVIGATION
- CONTROL PANEL FACTS
- COMMAND INTELLIGENCE

:Bridge - Interior

MAIN BRIDGE

The central area of the Main Bridge provides seating and information displays for the commander and two other officers. Directly fore of the command area are the Operations Manager and the Flight Control Officer, both of whom face the main viewer.

Directly aft of the command area is an elevated platform on which is located the tactical control station. Also located on the platform are five workstations, nominally configured as Science I, Science II, Mission Operations (Ops), Environment, and Engineering.

Stardate 48025.3239

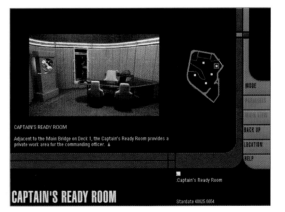

CAPTAIN'S READY ROOM

Adjacent to the Main Bridge on Deck 1, the Captain's Ready Room provides a private work area for the commanding officer.

:Captain's Ready Room

CAPTAIN'S READY ROOM

Stardate 48025.6654

TEN FORWARD

HOLODECK

EXTERIOR DETAILS

TRANSIT MODE

ADVENTURE GAME

The Dark Eye—based on the stories of Edgar Allan Poe—consists of a 3-D universe divided into four separate worlds, two of which are shown here. It features the distinctively rough voice of William S. Burroughs, the main character who narrates the game and reads two of Poe's short stories in their entirety.

The Dark Eye's opening screen uses sepia tones; the colors and its artfully illustrated phrenology diagram set the mood for the haunting worlds of *The Dark Eye*. But the first design element that really engages the user's attention is the hand, an element used for navigation throughout the game. The use of a real hand as a cursor, translucent when nothing is activated but solid when it rolls over an active element, adds an eerie feeling to the game. The hand's ability to grasp objects such as door knobs, and to point in the direction of navigation makes for even more eeriness.

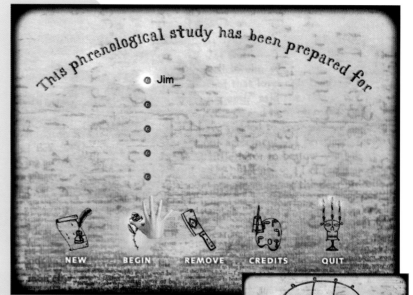

The Dark Eye interface enables interaction with other characters to obtain hints and clues that help to solve the mystery of each world. There are many pitfalls, though; seemingly harmless actions like searching other character's eyes for clues or gazing into a shiny knife cause blackouts after which players can come to in another world such as the one shown below, based on Poe's *The Cask of Amontillado*. Upon exiting a room, time can shift; even upon immediate return to that same room, the user can lose hours, days, or a whole season.

As the user explores the various worlds, the phrenology diagram fills with uniquely illustrated art. Clicking on these illustrations (reading the bumps on the head) allows users to continue the game where they left off, or return to a world and explore it further.

 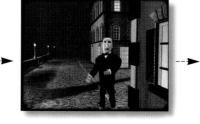 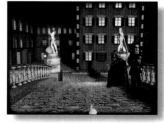

Project: *The Dark Eye*
Design Firm: **Inscape**
Creative Director: **Russell Lees**
Designers: **(see Developer's Listing)**
Programmers: **Erik Loyer, Brock LaPorte**
Authoring Program: **Macromedia Director**
Platform: **Mac/Windows**
Voiceover: **William S. Burroughs**
Music: **Thomas Dolby and Headspace**

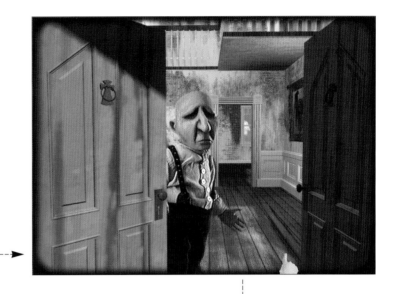

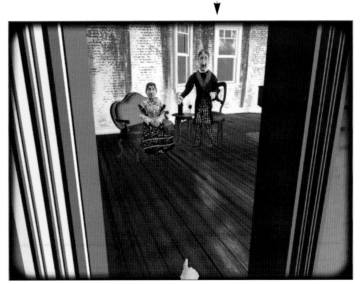

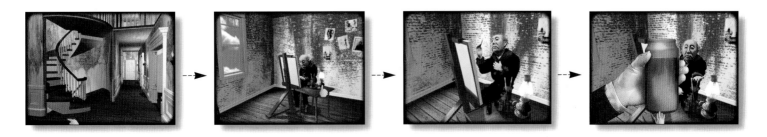

Microsoft Encarta '95 is an award-winning encyclopedia with access to text, images, audio and video. Its designers created an intuitive and accessible interface that allows users of all ages to explore a wealth of information. Using pull-down menus and button bars, users scan and easily search the enormous database of thousands of topics.

Several extremely useful elements are integrated into the interface, such as an illustrated timeline of world history, an interactive atlas that lets users view cultural and historic details of forty major countries, and a media gallery which gives the user access to thousands of images.

Icons representing each area and on-screen navigation tips allow for quick identification of the right information.

World of Encarta Getting Around Research & Reports

Project: *Encarta '95*
Client: **Microsoft**
Design Firm: **Microsoft Corporation**
Designer: **Bill Flora**
Illustrator: **Linda Bleck, Michael Coy**
Programmer: **Amy Raby**
Authoring Program: **Visual C++**
Platform: **Mac/Windows**

MANAGEMENT TRAINING

The New Leader: Communication, Cooperation, and Trust dodges the common problem of uninteresting tedium in traditional management training using video or lectures that makes it difficult for learning to take place.

Repurposing the same information in the form of an interactive CD-ROM makes the same material interesting and accessible. *The New Leader's* designer, Lightspeed Interactive, successfully repurposed text and video to create an engaging and comfortable environment in the form of a 3-D Alpine village, a virtual campus for first-level management training. The interiors of the buildings are well-crafted and help to extend the comfortable, engaging learning environment.

Learning sessions take place in several locations: in the café over a cup of coffee, in the library, at the theatre, and on a bench in the village park with a friendly stranger who just happens to be knowledgeable about management training. The vendor at the newsstand is also very helpful about management issues. These friendly and helpful villagers are actually videotaped actors filmed against a blue-screen background, and then incorporated into the rendered village.

Clicking on the palette at the bottom of each screen moves users to one of the four main areas of the village; clicking on unmarked hotspots takes them directly to their destination.

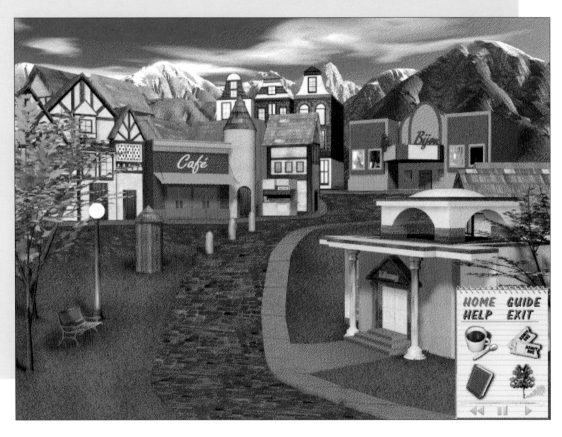

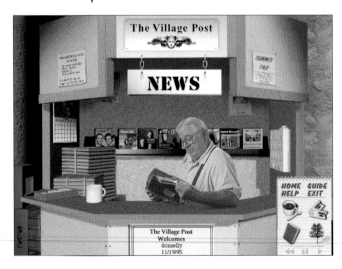

Project: *The New Leader: Communication, Cooperation & Trust*
Client: **Athena Interactive Inc.**
Design Firm: **Lightspeed Interactive Inc.**
Designers: **Shawn Nash**
Programmers: **Irv Kalb, Kevin Flores**
Writer: **Ira Ruskin**
Authoring Program: **Macromedia Director**
Platform: **Mac/Windows**

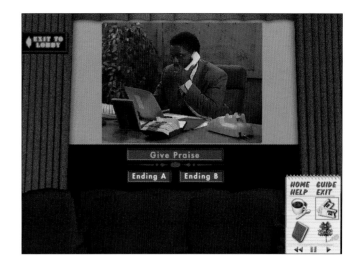

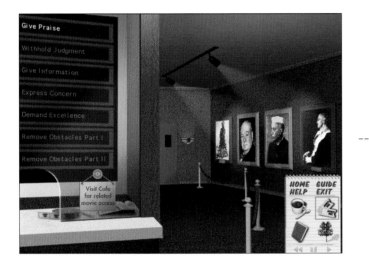

DIGITAL PORTFOLIO

CBO Interactive Premiere offers a humorous, in-depth look at the company (a division of the design firm Cimarron, Bacon, O'Brien) portfolio; this promotional piece shows the quality and creative potential that can be achieved when the full resources of a design firm are applied to a project.

Upon entering the theater, comedian Taylor Negron introduces himself as the box-office guide, and then follows users through the interface, encouraging them to interact with the beautifully rendered 3-D environment.

A menu bar at the bottom of each screen lists the large selection of interactive experiences to explore in the CD-ROM. Five different areas of the company's portfolio are navigable, including a QuickTime VR tour of CBO's Hollywood production facilities.

The portfolio features dozens of full-motion video clips of CBO's television and theatrical projects; it also lets users explore the music gallery where CBO presents CD cover designs it has created for major recording artists. Clicking on a CD cover opens its booklet, and a CD spins out as audio clips play.

Project: **CBO Interactive Premiere**
Design Firm: **CBO Multimedia, A Division of Cimarron, Bacon, O'Brien**
Executive Producer: **Robert Farina**
Creative Director: **Jill Taffet**
Designer: **Jill Taffet**
Illustrators: **Robert Vega, Luke Davis, Connie Nakamura**
Programmer: **John Peterson**
Photographers: **Eric Toeg, various**
Authoring Program: **Macromedia Director**
Platform: **Mac/Windows**

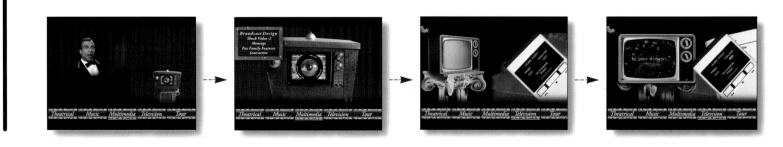

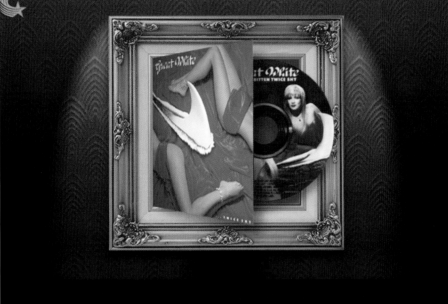

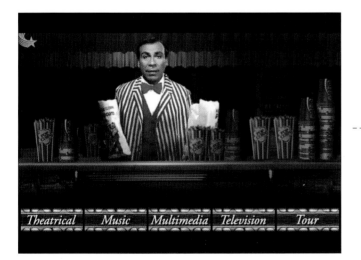

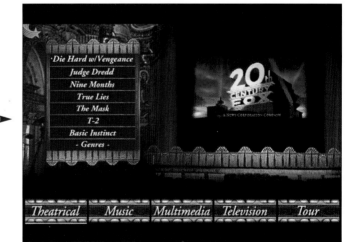

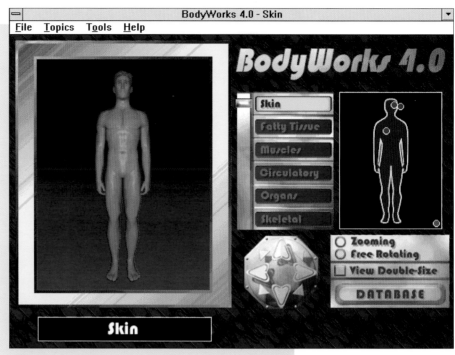

BodyWorks shows a simple, easy-to-follow interface from the opening screen. Various elements of human anatomy are placed next to a viewing window that shows hotspots that lead to specific regions or parts of the body for viewing. To the right of the main window is a navigation tool that allows the user to zoom into or away from the body, or rotate the figure left, right, up, and down.

A comprehensive health-care section, virtual fly-throughs of the body, and pop quizzes add to the instructional quality of the CD-ROM. One of the best qualities of *BodyWorks* is its comprehensive hypertext linking which allows a user to choose a subject and follow it through all sections of the CD-ROM.

What isn't noticeable upon first look at the interface is just how deeply the *BodyWorks* program allows the user to explore. Within easy access is an enormous amount of information about human anatomy: detailed illustrations, 3-D models, video movies and nursing sections are found on this CD-ROM.

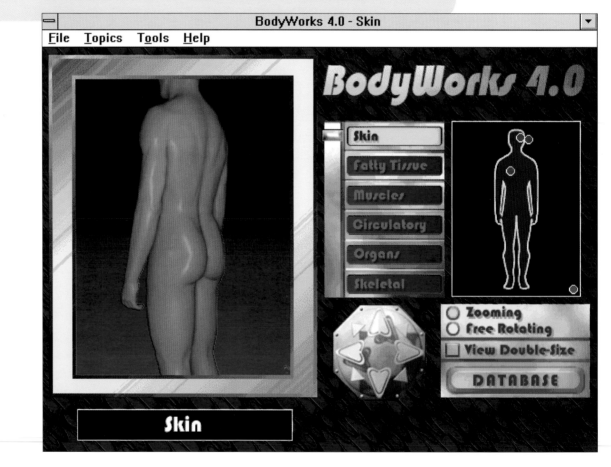

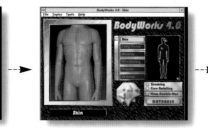 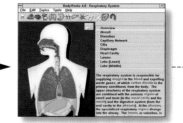 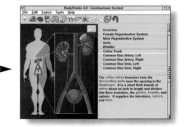

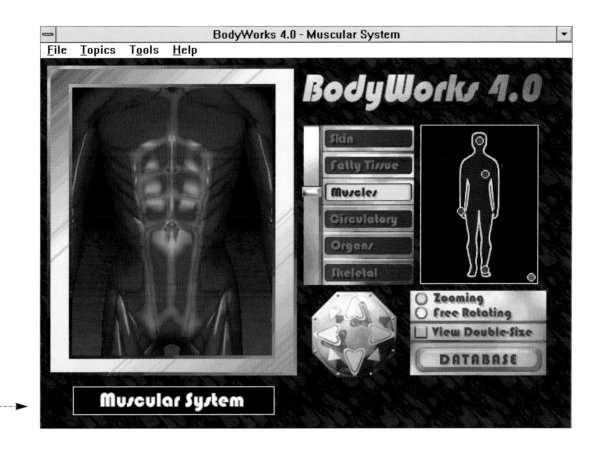

Project: *BodyWorks*
Design Firm: **SoftKey International**
Platform: **Mac/Windows**

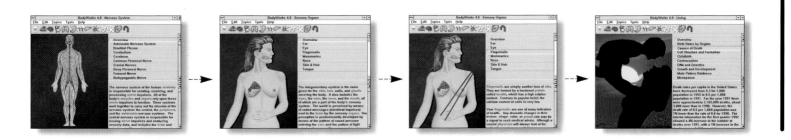

DIGITAL PORTFOLIO

Big Hand Productions' designers have realized the aim of the firm's portfolio, which is to summarize and showcase its extensive multimedia work. The design of the interface gives a feeling of movement, while the use of shading and layering evoke the illusion of a more intricate visual.

The portfolio's interface uses a single main screen for navigating its contents. This screen includes a volume slider bar, forward and backward buttons, an index button that allows the user to skip to a specific section, a background info button, and an exit button. Working with a monochromatic color scheme allows for prominent display of the design firm's projects. Big Hand's interfaces show an ability to adapt any project to multimedia, as can be seen in their designs for the "Australian Photographers" CD-ROM, Philips CD-i, and a Cadillac kiosk.

Project: **Digital Portfolio**
Design Firm: **Big Hand Productions**
Designers: **Staff**
Authoring Program: **Macromedia Director**
Platform: **Mac**

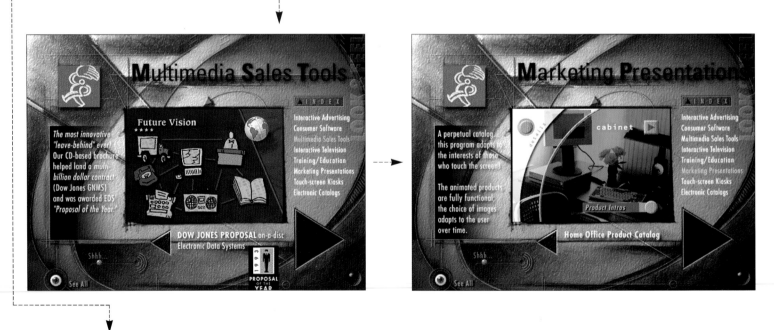

Interactive Advertising

First interactive magazine on CD-i... Over 10,000 copies distributed worldwide. What a freebie!

TABLE OF CONTENTS
FROM THE PUBLISHER
- FEATURES
- DEPARTMENTS
- CD-I SOURCEBOOK
- ABOUT CD-I WORLD

PLAY MODE

CD-I WORLD

INDEX
Interactive Advertising
Consumer Software
Multimedia Sales Tools
Interactive Television
Training/Education
Marketing Presentations
Touch-screen Kiosks
Electronic Catalogs

CD-i WORLD

CD-I ASSOCIATION 1992 SILVER
CD-I ASSOCIATION 1992 SILVER
INVISION 1993 FINALIST

Shhh...
See All

Training/Education

This interactive course replaces 4 hours of classroom material. Our design allows for group or in-depth individual study. Written by Philips' own Andy Davidson.

CD-I BIOLOGY
- CD-I Family History
- Anatomy of a Multimedia Machine
- Physiology of Digital Data

Play All

BIOLOGY 101

INDEX
Interactive Advertising
Consumer Software
Multimedia Sales Tools
Interactive Television
Training/Education
Marketing Presentations
Touch-screen Kiosks
Electronic Catalogs

CD-I BIOLOGY Interactive Courseware

CD-I ASSOCIATION 1993 SILVER

Shhh...
See All

The Gym

SNAPS MOVES
Standing 8 Count
Don't Go There
Stare Down
One Finger Hook
Flat Line
Long Dis
Roll 'n Neck (Tornado)

EXIT
90°

Multimedia Sales Tools

Grab their attention! Side-by-side animated demos of each chair in the line make Vecta's 4 O'Clock Disc a killer sales tool. A company overview backs up product info.

OVERVIEW
active passive
4 O'CLOCK SEATING
MORE... MORE...
EXIT
WELCOME DESIGNER TOUR TEST DRIVE DISC MAP

INDEX
Interactive Advertising
Consumer Software
Multimedia Sales Tools
Interactive Television
Training/Education
Marketing Presentations
Touch-screen Kiosks
Electronic Catalogs

VECTA 4 O'CLOCK SEATING

Shhh...
See All

NORTHSTAR
32 V NORTHSTAR

COMMERCIALS
DE VILLE SEVILLE
FLEETWOOD ELDORADO
CREDITS RETURN

Please Touch The Screen.
Personal Performance Car
ELDORADO TOURING COUPE

CADILLAC
Northstar
Privileges
Safety
RETURN

PROMOTIONAL PRESENTATION

Adobe Graphics Sampler was created as a promotional piece for Adobe Systems Inc. The disc includes demonstration versions of Adobe software, product tutorials, and an interactive art gallery, shown on these pages.

The CD's designers at Jive Turkey Productions chose a visual style that exploits the inherent limitations of digital video on CD-ROM, namely, lack of space. The disc uses small, tightly cropped video to achieve a particular visual feel, while reducing system demand and improving playback.

Two elements that add to the interface design are the original score by Andrew Diamond and an old-time car radio button used for navigating between the Sampler segments. The most distinctive attribute of the gallery is the designer's use of blue-screen technology to film artists and illustrators. With this technology, the designers were able to incorporate the artists directly into and on top of their exhibited work. On one of the more unique pieces, artist John Ritter is placed on top of an illustration and demonstrates his techniques by simulating drawing. In other areas, artists are shown from various angles demonstrating their art, and even appear as part of their artwork while narrating how it was conceived and rendered.

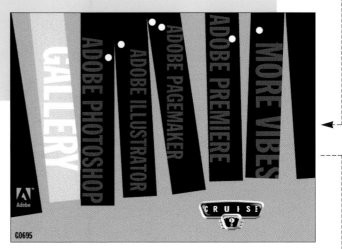

Project: **Adobe Graphics Sampler**
Client: **Adobe Systems Inc.**
Design Firm: **Jive Turkey**
Creative Director: **Ethan Diamond**
Designer: **Jonathan Caponi**
Music: **Andrew Diamond**
Video: **Glen Janssens**
Authoring Program: **Macromedia Director**
Platform: **Mac/PC**

JOHNRITTER
521 Francisco Street
San Francisco, CA 94133
Phone/Fax: 415.922.8577

volume 1 A COLLECTIVE IMPROVISATION BY THE ADOBE ALL STAR QUARTET **volume 2** PREMIERE STRAIGHT AHEAD **volume 3** PAGEMAKER COOL **volume 4** PHOTOSHOP SOUL CLINIC **volume 5** ILLUSTRATOR JAM SESSION

RONCHAN
24 Nelson Avenue
Mill Valley, CA 94941
Represented by Jim Lillie
415.441.4384

SOCIAL ACTIVISM

Amnesty Interactive is one of the most compelling social activism CD-ROMs. Designed to teach the concept of human rights and to promote Amnesty International's Universal Declaration of Human Rights, *Amnesty Interactive* draws strength from its moral and ethical message, and is supported by the visually appealing scratch art illustrations created by Nancy Nimoy. Using powerful black-and-white imagery, voiceovers, music, illustration, and video, the designers have created a uniquely personal look into the lives of victims of political and social strife.

The tone of the piece is set with the introductory screen, which segues into the contents screen with a startling machine gun sound. The buttons on the contents screen are beautifully rendered icons, each conveying a feeling of movement and urgency emblematic of the content to which they lead. Background art and borders carry the same look and feel as the contents screen, visually unifying the project.

The five sections carry a powerful statement, each introduced by Leonard Nimoy. The "Rights" section combines voiceover and stop-motion animation; "Ideas" leads to a timeline of important happenings; "Voices" comprises interviews and music by activist singers such as Jackson Browne and Peter Gabriel.

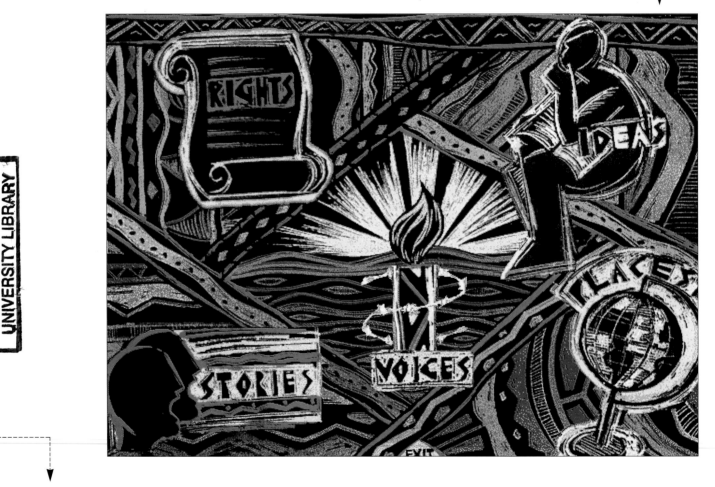

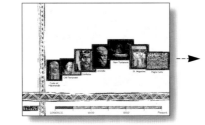

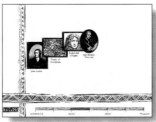

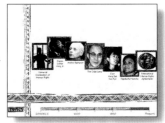

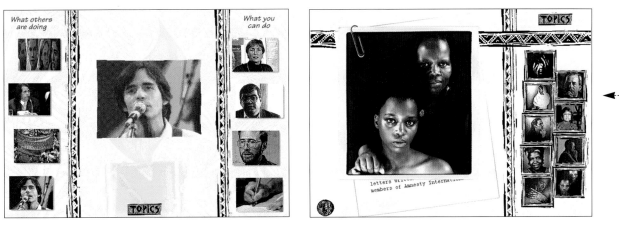

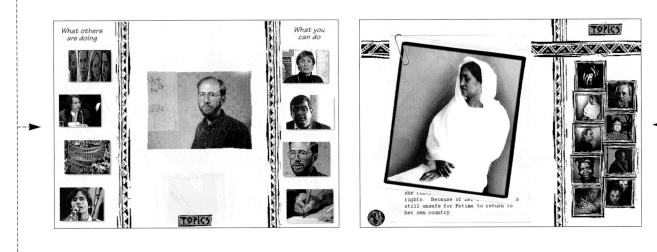

Project: **Amnesty Interactive**
Client: **Amnesty International USA**
Design Firm: **Ignition**
Designers: **Ray Kristof & Eli Cochran**
Illustrator: **Nancy Nimoy**
Programmers: **Eli Cochran, Chris Thorman**
Voiceover: **Leonard Nimoy**
Authoring Program: **Macromedia Director**
Platform: **Mac/Windows PC**

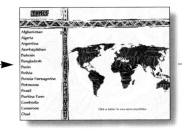

EDUCATIONAL/REFERENCE

Events That Changed The World uses an interface that displays unparalleled creativity. From the opening screen to the end credits, the designers achieve a uniform level of artistic and technical excellence. The designers skillfully blend various elements of the interface to create a memorable and fulfilling insight into historical events.

To create a clean and uncluttered interface, the designers give users discretion over which of the main navigational tools they wish to have displayed. A marble-textured bar along the side of the screen allows the users to hide or reveal buttons with a single click. Shadows and highlights are used throughout the interface to create a sense of drama and depth, while illustrations used for backgrounds and frames look as if they have been projected onto a 3-D surface.

Project: *Events That Changed the World*
Design Firm: **ICE**
Designers: **Pete O'Neil, Simone Paradisi, Sean Patrick, Steven Wicks**
Illustrator: **Robert Ingpen**
Producer: **Michael Plexman**
Programmers: **Darryl Gold, Pete O'Neil, Steven Wicks**
Authoring Program: **Macromedia Director**
Platform: **Mac/Windows**

a-b
c
d-g
h-j
k-l
m-n
p-r
s-z

Alexander I, Tsar
Amherst, Jeffrey
Appia, Louis
Aquinas, Thomas
Aristotle
Asoka
Augustine, Saint
Augustus, King Philip II
Aztecs
Bagration, Prince
Becquerel, Henri
Bedford, Duke of
Bindusara
Bohr, Niels
Bolivar, Simon
Bonaparte, Napoleon (Battle of Trafalgar)
Bonaparte, Napoleon (Fall of the Bastille)

who?

EXIT Click on the name window or the alphabet

Page 1 of 3

300 BC 1000 AD 1300-1400 AD

0000 AD 1200 AD 150

-1000 0000 1000 1100 1200 1300 14

EXIT You are at the main menu of the When navigator

Page 1 of 2

CULTURAL STUDY

Selected Notes 2 ZeitGuys is a collaborative work that seeks to connect the 126 collected illustrations that comprise the ZeitGuys font. This piece of interactive writing is the largest in a series of interactive font projects created by Aufuldish & Warinner.

Published by the Center for Design Studies at Virginia Commonwealth University, Mark Bartlett wrote a pun-filled text based on the subtleties of French cultural theory that attempts to connect the Guys. Bob Aufuldish then designed pages based on Bartlett's writings. Beginning with the opening screen, each subsequent screen of the project appears out of focus; by moving the cursor around the screen, bits and pieces of the blurred image pop up in focus, accompanied by Bartlett's writings. This pop-up feature activates the process of navigating the interface by maintaining the full attention of the user, in much the same way as road signs keep a driver's attention.

Project: **Selected Notes 2 ZeitGuys**
Client: **Zed: The Journal of the Center for Design Studies at Virginia Commonwealth University**
Design Firm: **Aufuldish & Warinner**
Designer: **Bob Aufuldish**
Programming: **David Karam**
Writer: **Mark Bartlett**
Sound: **Bob Aufuldish**
Icons: **ZeitGuys by Eric Donelan and Bob Aufuldish**
Authoring Program: **Macromedia Director**
Platform: **Mac**

click on a page to see it again

click on exit to leave

EX IT

text by **Mark Bartlett**

design by **Bob Aufuldish**

images by **Eric Donelan**

Eric Donelan
statement about *the images*

Mark Bartlett
statement about *the text*

Bob Aufuldish
statement about *the design*

Selected Notes to ZeitGuys

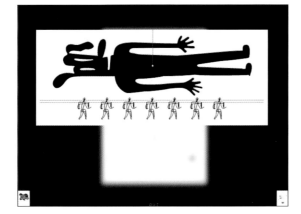

Eric Donelan

ZeitGuys is a collection of 126 images in font format which form a new poetical language to buttress the burned-out shell which is alphabetic communication.

ZeitGuys is an endless "Exquisite Corpse" with each author redefining the image-language, infusing it with particular meaning where before there was none.

Moreover, because of the prevalence of font piracy worldwide, these images will become global, and have the potential to become symbols with different meanings in different cultures. Thus ZeitGuys could be thought of as the first symbol virus to spread worldwide.

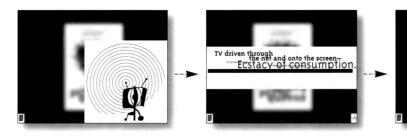

TV driven through the net and onto the screen— Ecstacy of consumption.

porno queens!

DIGITAL PORTFOLIO

Between Earth and The End of Time is a journey into the worlds of painter/illustrator Rodney Matthews, a journey where users examine Matthews' painting techniques and creative processes while viewing interviews with the artist, and browsing through hundreds of pieces of fantasy art. Incorporated into the interface navigation is a scavenger hunt game where the user collects words hidden throughout the CD-ROM, which are later used to solve a puzzle.

The main interface, a three-dimensional image of layered marble columns and entryways, is complemented by the use of light and shadow to create depth, adding to the overall feeling of entering Rodney's world of fantasy. The columns are used not only to frame the interface and the videos, but also to incorporate a number of navigational buttons.

Another innovative technique that draws the user into the content is shown below in the first four panels. This interface allows the user to create a collage-like painting by choosing pieces of Matthews' art and then layering them on top of each other. This same technique is repeated in the "Build Your Own Logo" section of the interactive.

Two other items that add to the richness of the interface are the ability to view video in 8-bit or 16-bit format, and short trivia games that are incorporated into the different galleries of his paintings.

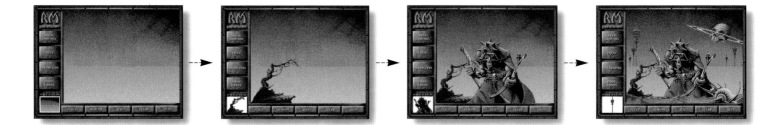

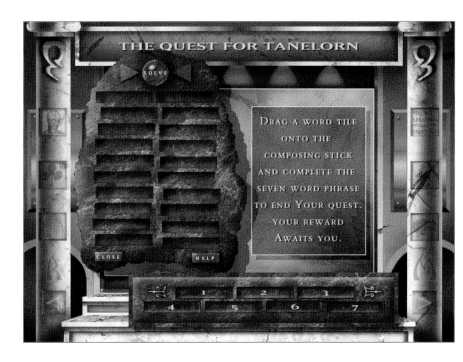

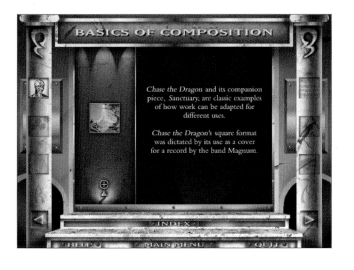

Project: *Between Earth and the End of Time*
Design Firm: **ICE**
Designer: **Steve Beinicke**
Illustrator: **Rodney Matthews**
Programmer: **Margaret Beck**
Authoring Program: **Macromedia Director**
Platform: **Mac/MPC**

INTERACTIVE GAME

Leonardo the Inventor encourages interactive exploration of the inventions and life of one of the world's great thinkers and artists.

The interface for navigating the CD-ROM features easily identifiable buttons that link the user to six main areas, characterized by thoughtful detail like easy-to-read, anti-aliased type on the biography text. Users access information easily, with no more than three layers separating them from desired content. The use of parchment as a background on each screen evokes a sense of studying Leonardo's original time-worn sketches and illustrations.

Perhaps the most creative detail of the project is the ingenious animation of Leonardo's sketches of flying inventions—though they never flew in life, they do fly here in virtual reality.

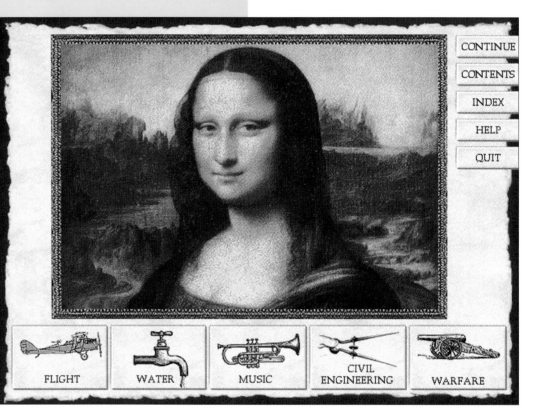

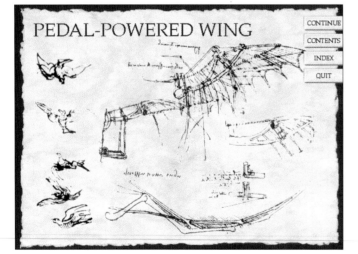

Project: *Leonardo the Inventor*
Design Firm: **SoftKey International**
Platform: **Mac/Windows**

America's Funniest Home Videos' CD-ROM game, entitled *Lights! Camera! InterAction!* has something to offer couch potatoes, would-be film editors and game players.

Lights! Camera! Interaction! takes place in a suburban American house with three playing levels. Those who tear themselves away from the couch potato level will find the editing level on the second floor, and the game room in the attic.

The three levels in the house are three-dimensional rooms where all of the interaction takes place. Each level of the house requires varying degrees of user involvement. The first floor lets users sit back and run through dozens of home videos, the second floor has an editing suite where users splice together their own home videos from stock footage, and the attic lets users play a game.

The 3-D design and interactivity of the helper arrows show an unusual amount of forethought and planning, compared to help features found in most other interactive projects.

Project: *America's Funniest Home Videos Lights! Camera! InterAction!*
Design Firm: **Graphix Zone Inc.**
Designer: **Susan Dodds**
Programmers: **Bill Pierce, Sean Dunn**
Authoring Program: **Apple Media Tool Kit**
Platform: **Mac/Windows**
Production Date: **October 1995**

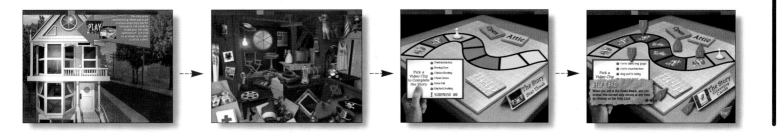

EDUCATIONAL/REFERENCE

Exploring Ancient Cities, a creative venture from *Scientific American* and Sumeria Inc., examines four lost cities from antiquity: Teotihuacán; Petra, in present day Jordan; Pompeii, the Roman town once buried in lava; and Minoan Palaces on the island of Crete.

The CD-ROM uses an attractive, simple interface. Clearly labeled icons on the contents screen and identifying images representing the four cities are placed on a weathered stone background. The designers maintain continuity from this opening screen by using the identifying images as backgrounds on successive screens.

Exploring Ancient Cities blends text-based information in the form of comprehensive essays by respected archaeologists with visual learning aids in the form of a scrolling timeline, city maps and reconstructions, as well as a wealth of photographs.

One of the ways to take in the CD-ROM's content is a self-running tour, narrated by Rod McKuen.

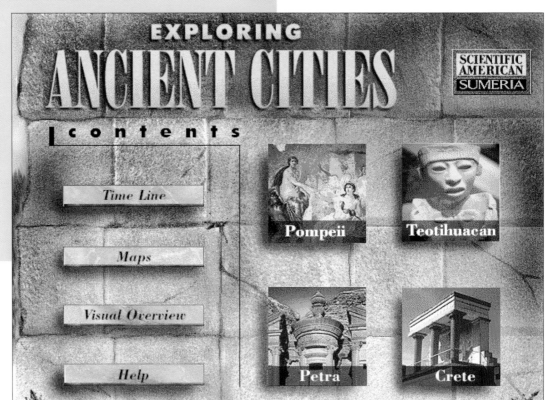

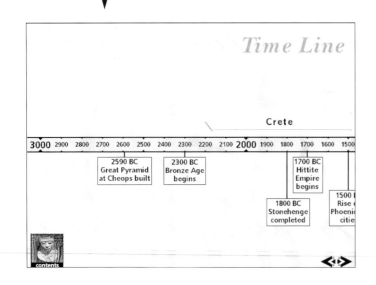

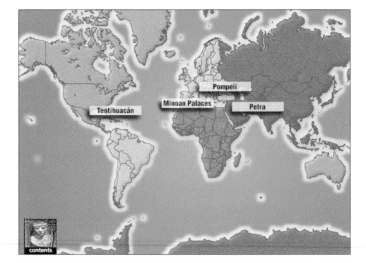

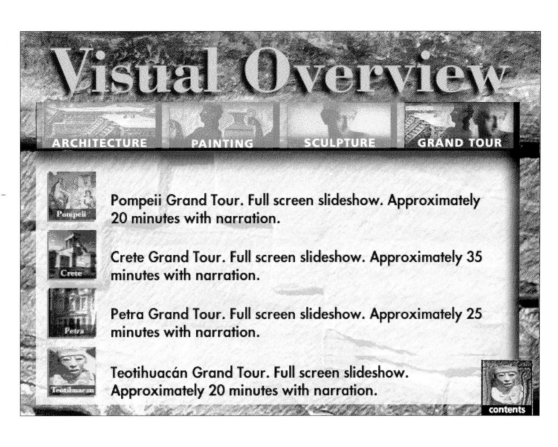

Visual Overview

ARCHITECTURE PAINTING SCULPTURE GRAND TOUR

Pompeii Grand Tour. Full screen slideshow. Approximately 20 minutes with narration.

Crete Grand Tour. Full screen slideshow. Approximately 35 minutes with narration.

Petra Grand Tour. Full screen slideshow. Approximately 25 minutes with narration.

Teotihuacán Grand Tour. Full screen slideshow. Approximately 20 minutes with narration.

contents

contents

Project: *Exploring Ancient Cities*
Design Firm: **Sumeria Inc.**
Executive Producer: **George Reynolds**
Designer: **Andrew Faulkner**
Map Designers: **Arne Hurty, Stephen Muller**
Narration: **Rod McKuen**
Additional Credits: **(see Developer's Listing)**
Platform: **Mac/Windows**

Pompeii
by Amedeo Maiuri

The eruption surprised Pompeii on a warm August day A.D. 79. The people of the town were not unaware that Vesuvius was a volcano, but it had been quiescent from time immemorial, and its slopes were covered with villas and vineyards. Although sections of the city still lay in ruins from a local earthquake that had shaken the region 17 years before, no one had taken that disturbance as a warning of the disaster to

Originally published: April 1958

CITY MAP

contents

Teotihuacán
By René Millon

When the Spaniards conquered Mexico, they described Montezuma's capital Tenochtitlán in such vivid terms that for centuries it seemed that the Aztec stronghold must have been the greatest city of pre-Columbian America. Yet only 25 miles to the north of Tenochtitlán was the site of a city that had once been even more impressive. Known as Teotihuacán, it had risen, flourished and

DIGITAL MAGAZINE

just think is an interactive political/cultural magazine published on CD-ROM. The second issue, shown here, reflects the high quality of design and illustration that users expect while exploring the magazine.

The contents screen gives users easy access to the articles featured in the issue with text and icons representing the articles. As in traditional magazine design, each article is given a different look through the use of illustration, video, and photography.

One of the most unique features in *just think's* design is the "Quebe", a 3-D navigational cube that is used in all of ad•hoc s interfaces. This navigational device spins across the screen from left to right, and disappears in reverse once a side of the Quebe has been selected. The Quebe offers access to the contents, help, tools, or exit buttons when it is rotated top to bottom, or left to right.

Project: *just think (an interactive)*
Design Firm: **ad•hoc Interactive, Inc.**
Designers: **Megan Wheeler, Aaron Singer, Shawn McKee**
Illustrators: **Megan Wheeler, Ray Ferro, Craig Brown**
Programmer: **Shawn McKee**
Authoring Program: **Macromedia Director**
Platform: **Mac/Windows**

DIGITAL JOURNAL

Interact, the journal of the American Center for Design, adheres to the foremost goal in its creation: to make the interface engaging and provocative, while requiring only a minimum of Macintosh familiarity. Targeted to the design community, this interface invites exploration and discovery, encouraging the audience to have fun while navigating through the CD.

Instead of congregating individual buttons in a single location, *Interact* uses a map-like interface that forces users to scroll around the interface to view various design element islands that serve as links to individual interactive works.

Clicking and holding the mouse button pulls up a description of the interactive work, while double-clicking the mouse takes the user to the interactive work listed. The control layer is pushed behind the active work to avoid intruding on the immediate content.

click on an item to see what it's about

Interface, Display and Hardware Fantasies for the New Broadband
P. Scott Makela
Don Carr

Cranbrook Academy of Art

User Interface Design

for Information Products in the Wired Society
Aaron Marcus and Associates

Elisabeth Waymire
Bruce Browne

The Evolution of a Software Identity

Project: *Interact*—American Center for Design Journal
Client: **American Center for Design**
Design Firm: **IDEO**
Designer: **Peter Spreenberg**
Contributing Designers: **(see Developer's listing)**
Programmer: **Peter Spreenberg**
Authoring Program: **Macromedia Director**
Platform: **Mac**

Blank Models

Michael Arent

Richard Mander

a method for

Early User Participation

Video Producer is an award-winning course that teaches the creation of clean, professional video. Using an interface that resembles a live-video production suite, users train in various aspects of video production: camera usage, lighting, audio, editing and the process of video production.

The navigation of the content is simple, with icon-based buttons used along with text treatments to allow for ease of recognition. But what pulls the design together and makes it a useful source for interactive training is the extensive use of narration and video for all of the exercises.

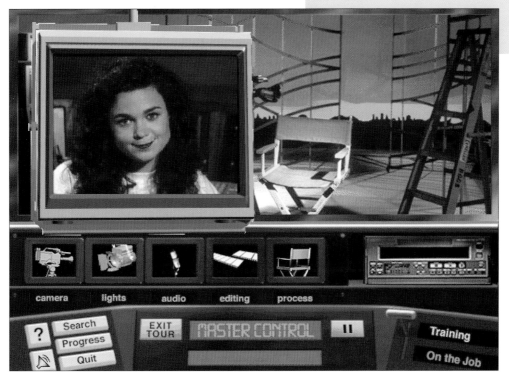

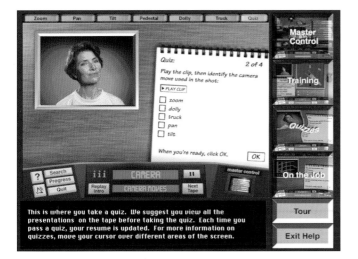

Project: **Video Producer**
Client: **Wadsworth Publishing**
Design Firm: **Cooperative Media Group**
Interface Designer: **Jeff Caton**
Instructional Designers: **Jeff Caton, Jeff Katzman, Jeff Larsen, Chris Pitts**
Illustrators: **Jeff Caton, Mark Straka, John Beebe**
Programmers: **Jeff Katzman, Rob Danbin**
Photographers: **Ken Smith, Jeff Caton**
Authoring Program: **Authorware**
Platform: **Mac/Windows**
Production Date: **Mac/October 1995, PC/August 1996**

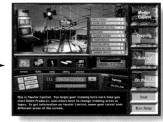

ADVENTURE GAME

Myst is a leader in the world of interface design. With its invisible buttons and an extremely intuitive interface, *Myst* compels the viewer to explore and navigate the island, even before the goal of the game is clear. Because of its success in creating such an alluring interface, *Myst*'s navigational properties are being duplicated in many interactive CD-ROMs.

Myst uses a seamless navigational interface comprised of invisible clickable buttons to move from room to room and to navigate the island. Avenues of exploration are designed into objects such as books and paintings in the library, or an old book lying conspicuously on a chair.

Of extreme importance is *Myst*'s use of texture to convey a feeling of realism: light reflecting off dull metal; the grain of wood in the library or on the ship; narrow, dimly lit passageways leading to underground caverns with deep shadows.

Each adds to *Myst*'s unique interface and flavor while enhancing the intrigue and mystery of where the island's occupants have gone.

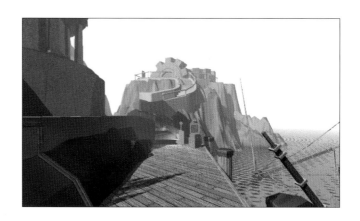

Project: *Myst*
Client: **Brøderbund**
Design Firm: **Cyan**
Designers: **Rand Miller, Robyn Miller**
Authoring Program: **Source code**

PROMOTIONAL PRESENTATION

Novell's *NetWare Multimedia* promotion, designed by Lightspeed Interactive, uses vibrant colors and a futuristic 3-D design to create a dynamic interactive experience. This project pushes the boundaries of the traditional corporate presentation, resulting in a successful sales and marketing tool.

The main menu offers users three areas to navigate, as well as an unobtrusive menu bar placed at the bottom of the screen, accessible at all levels of the interface. One of the most innovative elements of the design is the use of rendered 3-D icons that pop up above the menu bar and spin or rotate when the cursor rolls over a button. A perspective grid for a background surface creates an illusion of depth and distance, adding to an interface that is already characterized by 3-D shapes and images.

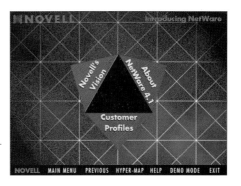

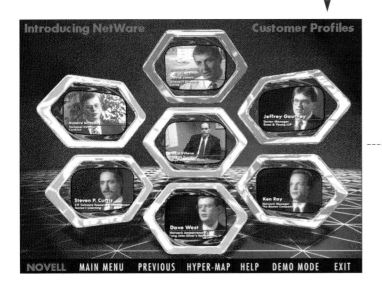

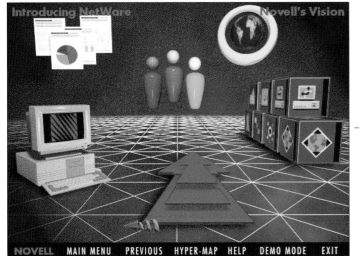

Project: *NetWare Multimedia*
Client: **Novell Inc.**
Design Firm: **Lightspeed Interactive, Inc.**
Creative Director: **Kevin Flores**
Designers: **Jeanine Panek, Ian Atchison, Shawn Nash**
Programmer: **Kevin Flores**
Video: **Breene Kerr Productions**
Authoring Program: **Macromedia Director**
Platform: **Mac/Windows**

PROMOTIONAL PRESENTATION

Architects of a New Medium is an award-winning CD-ROM that lets users explore a multimedia world created by Micro Interactive. Using an architectural site plan as its main contents screen, the designers created an exceptionally integrated interface.

By exploring virtual 3-D rooms within allegorical buildings, the user gains firsthand information regarding the company's design processes for major clients. Impressive multimedia elements, such as the placement of a video presentation on a laptop computer screen, an animated character on a 35mm film strip, or the use of a blueprint for navigating rooms demonstrate Micro Interactive's creative and technological capabilities.

The most important element of the interface is the use of well-written narration, which conveys most of the information to the user. Explorers of the virtual environment are greeted by an audio guide, who explains each room's purpose and relationship to the goals of the company.

By clicking on elements in each room, the user learns more about the approach Micro Interactive takes toward determining and fulfilling the client's needs.

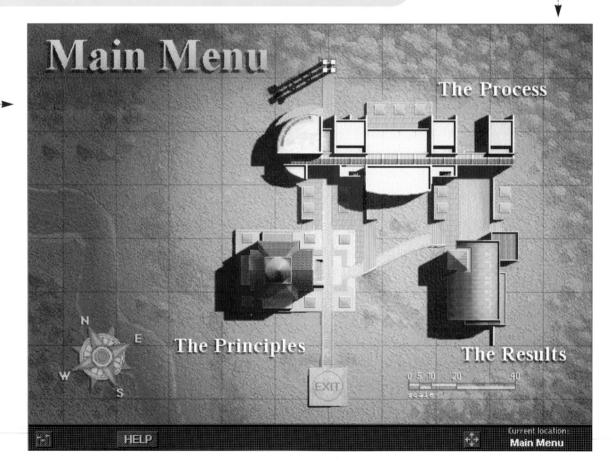

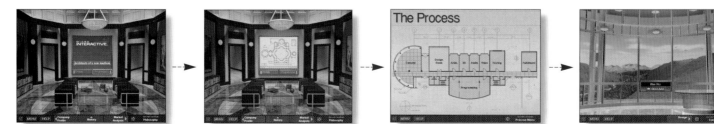

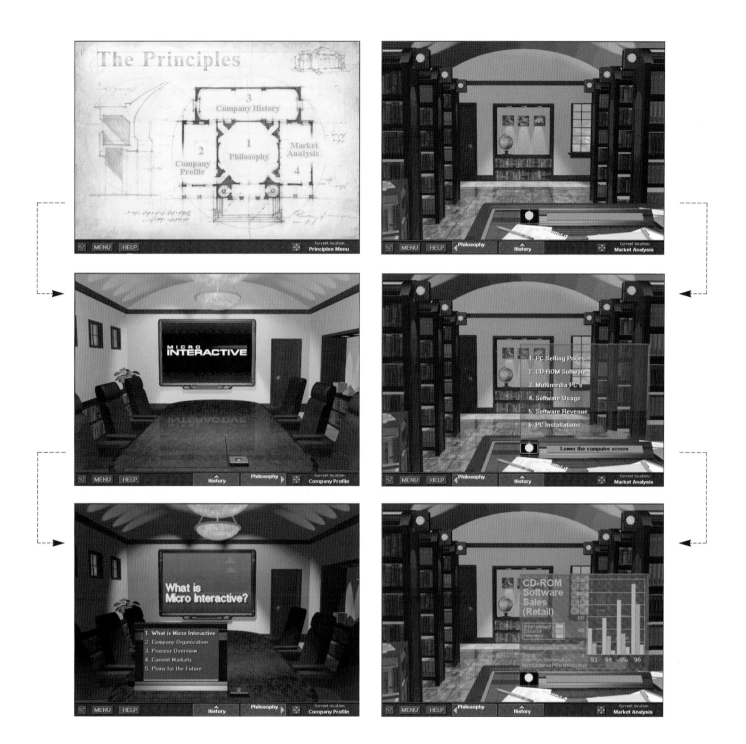

Project: *Architects of a New Medium*
Design Firm: **Micro Interactive Inc.**
Creative Director: **Eric Freedman**
Designers: **Staff**
Illustrators: **Staff**
Programmers: **Derrick Shriver, Staff**
Authoring Program: **Proprietary**
Platform: **Windows**

SELF-HELP/INSPIRATIONAL

Love, Medicine & Miracles from Dr. Bernie Siegel offers an effective adaptation of his inspirational workshops and books to an interactive CD-ROM format. The nature of this material and the target audience required an inviting and completely unintimidating interface and creative handling of unusual tasks, such as guided meditation and journal keeping.

In keeping with the structure of Dr. Siegel's workshops—where attendees are encouraged to explore personal aspects through the material—a video form of Dr. Siegel guides users through each workshop and section of the CD.

With soft colors and peaceful images, large clear type, and concise, simple text-driven navigation buttons, *Love, Medicine & Miracles* is easy to follow. One notably user-friendly feature is the scrapbook, which allows users to clip and save text, audio, and video segments for later review.

Love, Medicine & Miracles features an automatic connection to Dr. Siegel's forum on America Online. This feature is a sign of the imminent convergence of multimedia and the Internet.

Project: *Love, Medicine & Miracles*
Design Firm: **HarperCollins Interactive in conjunction with Imergy**
Editor/Producer: **Carolyn Cahill**
Producer (Imergy): **Ray Billings**
Lead Artist (Imergy): **Dale Robbins**
Creative Director (Imergy): **Debra Leeds**
Programmer (Imergy): **Mitch Grasso**
Authoring Program: **Macromedia Director**
Platform: **Mac/Windows**

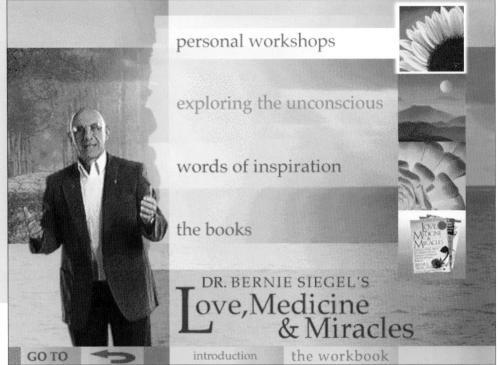

EDUCATIONAL/REFERENCE

Marsbook CD, produced by Human Code in 1993 for NASA, is a virtual guide to NASA's Initial Planned Mars Habitat. It was created using an early version of what was then MacroMind Director and used the first release of QuickTime—as such, it represents an immense effort of 3-D rendering and data organization. Remarkably, this presentation is satisfying even though there is no audio track. The intricate detail of the rendering, the ability to zoom in and examine visual detail, and the precise engineering notes are accessed quickly, quietly and efficiently, seemingly in the silence of space.

Five "LevelKeys" allow viewers to examine both the interior and exterior of each level in the station in several ways: as wireframe floor plans, as fully rendered diagrams showing construction dimensions and mechanical cutaways, or as interactive video walkthroughs. The viewer controls the direction and speed of walkthroughs using the small Navigation Window in the upper left corner. Clicking on an object in the Navigation Window interrupts the tour and displays a detailed 24-bit color image of the object in the large display window, and descriptive text in the information window below. When viewing exterior images of the habitat, the Navigation Window displays a thumbnail image that rotates in any direction by clicking and dragging. The rotated image is then displayed in large format on the main viewscreen.

Additionally, a lunar module is accessible for viewing via the NASA control panel under the text box. Though not as obsessively detailed as the Mars Habitat presentation, several walkthrough presentations are available.

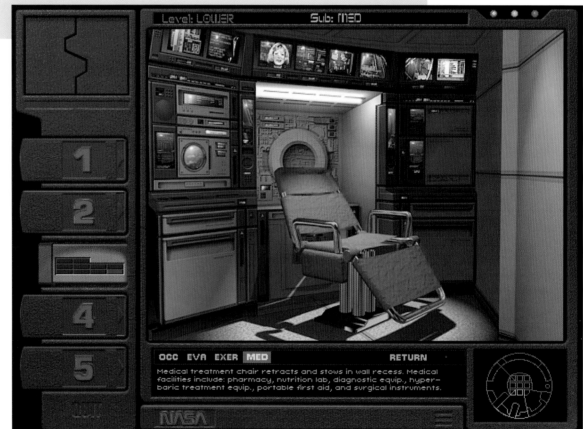

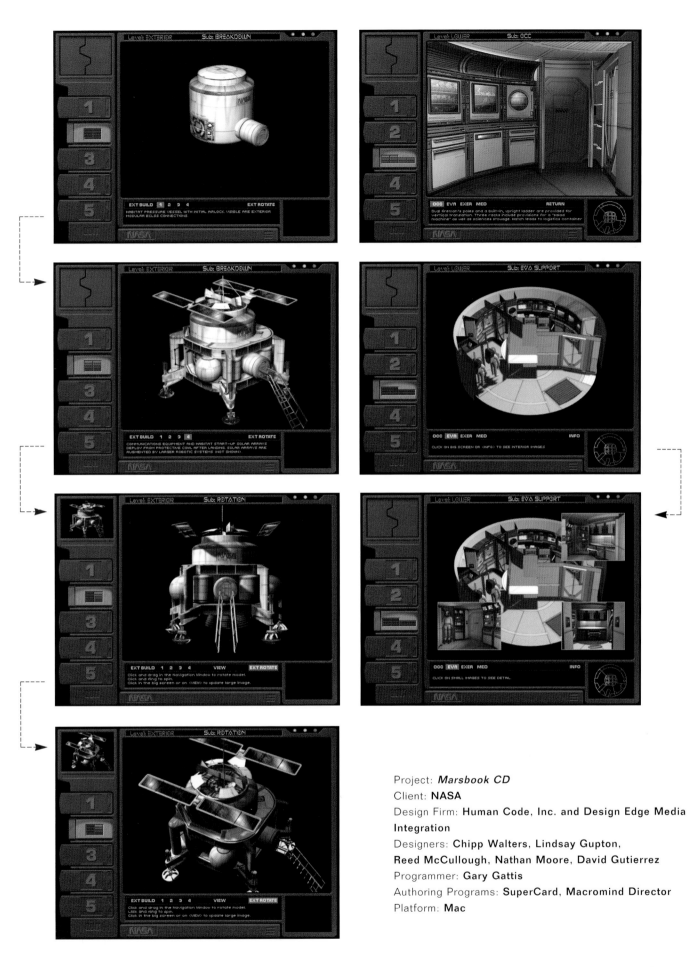

Project: *Marsbook CD*
Client: **NASA**
Design Firm: **Human Code, Inc. and Design Edge Media Integration**
Designers: **Chipp Walters, Lindsay Gupton, Reed McCullough, Nathan Moore, David Gutierrez**
Programmer: **Gary Gattis**
Authoring Programs: **SuperCard, Macromind Director**
Platform: **Mac**

EDUCATIONAL/REFERENCE

Material World is a well-crafted tool that allows the user to experience cross-cultural realities. An intimate look into the lives of families from around the world, this CD-ROM lets users explore lifestyles and customs of these families by examining their belongings and viewing a scrapbook of their lives. Sixteen of the world's foremost photojournalists traveled to thirty nations to live for a week with a family; the spread pictured here focuses on the Qampie family of Soweto, South Africa.

The project opens with a slide show of images from the CD-ROM, accompanied by a voiceover by Charles Kuralt. To keep the interface easy to use, the designers use four buttons on the contents screen, which link to the four main areas of the CD-ROM. This principle of limiting the available choices of each screen is used throughout the interface, allowing the user to focus on content rather than decision-making.

A button bar across the top offers universal navigation utilities such as return, print, and help buttons. The use of illustrations for elements—icons and backgrounds—softens and personalizes the interface, as well as emphasizes the photography.

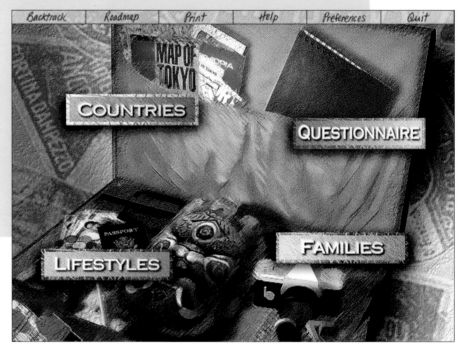

Project: *Material World: A Global Family Portrait*
Development Firm: **StarPress/Watts-Silverstein**
Producer: **Mark Williams**
Photographer: **Peter Menzel (Primary)**
Authoring Program: **Macromedia Director**
Platform: **Mac/Windows**

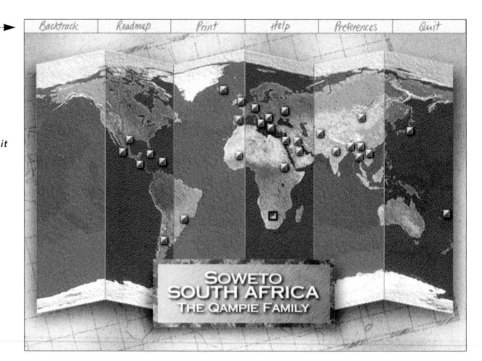

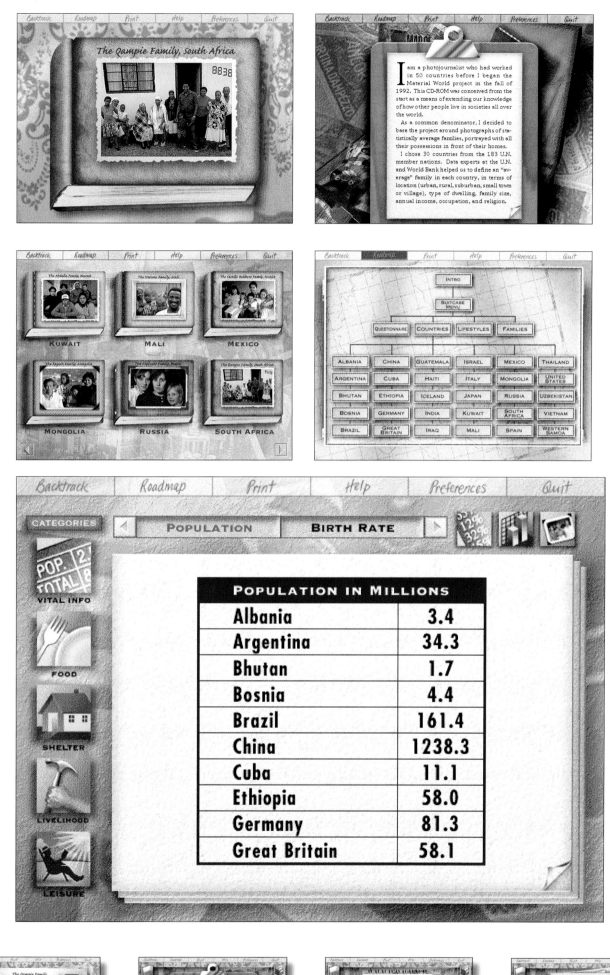

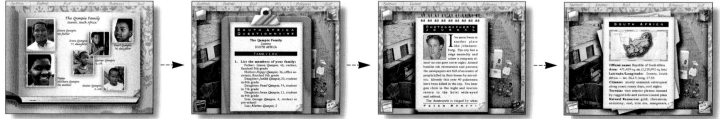

DIGITAL CATALOG

MusicNet is a quarterly interactive music catalog that features more than two hundred albums covering rock, jazz, blues, country, and world music.

The interface allows users to quickly identify favorite music types by offering several different ways to sort them: by album title, artist, video, audio, or complete index. Each album listing features three audio clips and a video or cover from the album. The top section of the interface displays icons indicating whether the album features video or straight audio.

By placing the shopping list area on the main contents screen, the designers make it easy for the user to see how many albums they have chosen, add new albums, or delete unwanted selections. *MusicNet* also includes a special promotional area where advertisers showcase their products in an interactive format, featuring video and audio tracks.

Project: *MusicNet* CD-ROM

Design Firm: **MNI Interactive, Inc.**

Designer: **Dr. Michael Mills**

Illustrator: **Dan Esmey**

Programmers: **Leo Degen, Sam Hammond**

Authoring Program: **C++**

Platform: **Mac**

TRAINING/RECREATION

The Martial Arts Explorer offers four different paths of discovery, all accessible from the main contents screen. Each path is represented by an icon that, when clicked, takes users to a different world. Each world has a distinctive look, characterized by Far Eastern art, such as pagodas on the "Explorer's island," an acupuncture model in the "library," or the "journal" used for viewing martial arts techniques.

Two additional contents screen elements include a help button, which activates a small video when clicked, and a preferences box, sliding back to reveal a mechanical simulacrum of the interface.

Of all the areas featured on the CD-ROM, the most useful and entertaining is the library. Clicking on a specific area of interest lets the user view instructional videos of martial arts techniques.

A Far Eastern influence felt throughout the CD-ROM adds to the atmosphere of the interface, making users feel as if they have actually visited the worlds of *The Martial Arts Explorer.*

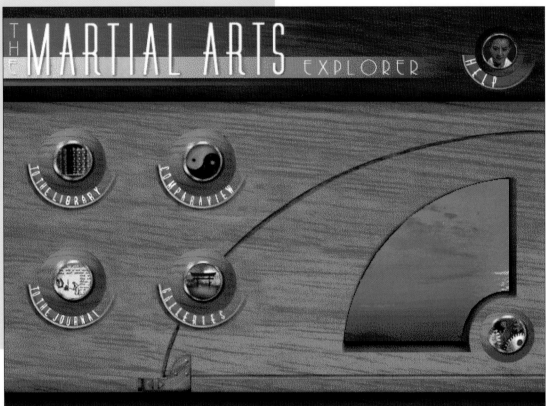

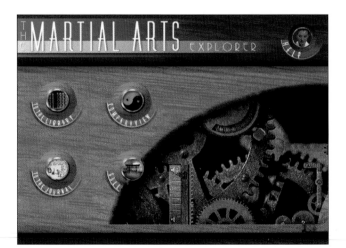

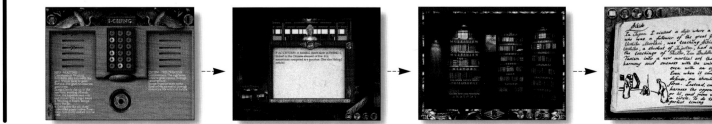

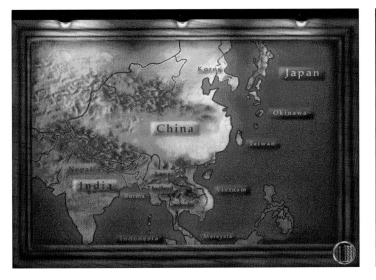

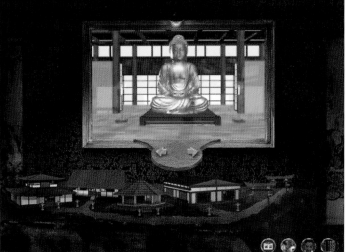

Project: *The Martial Arts Explorer*
Design Firm: **SoftKey International**
Designers: **Staff**
Platform: **Mac/Windows**

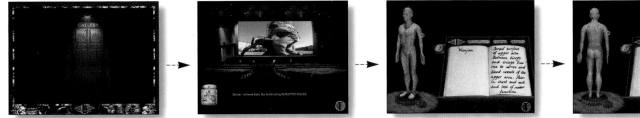

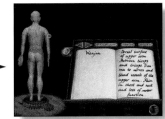

DESIGN SOFTWARE

MetaTools' interfaces all share in common the conceptual vision of Kai Krause, designer of Kai's Power Tools (KPT) Photoshop plug-ins and the landscape-generating Bryce software. Considered by many to be one of the most eclectic and creative interface designers of modern time, Krause's designs garner world-wide notoriety with their unique shapes and forms.

For the most recent release of KPT, Krause created several fun, functional interfaces. The KPT Lens f/x tool, futuristic and stop-watch-like in design, drags across an image and shows how various filter effects will look on a final piece of art. In contrast to this high-tech design is the "organic" interface created for the Spheroid Designer tool (at right).

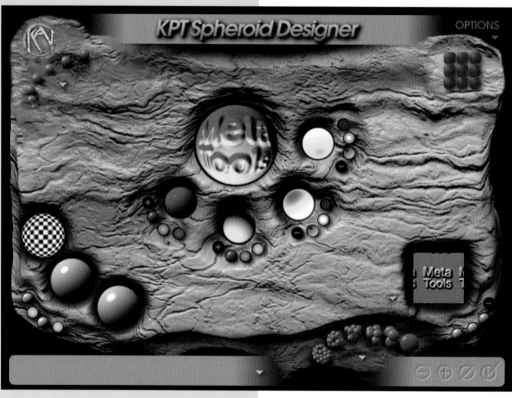

KPT Bryce is one of the most amazing programs to be released in the past few years.

Four main palettes enable the creation of spectacular 3-D landscapes and scenery. In a major upgrade to the original version (shown at bottom, opposite page), Kai has added to an already intu-itive interface: more shapes have been added for render-ing complex images, and the overall interface has been streamlined for easier access to specific functions.

Aside from innovative inter-face design, all of these inter-faces feature rollover text help and fast previews. Perhaps the most important aspect of these interface designs is that they invite users to immediately begin using them as design tools.

Project: **KPT/Bryce**
Design Firm: **MetaTools**
Designers: **Kai Krause/Staff**
Authoring Program: **Proprietary Software**
Platform: **Mac/Windows**

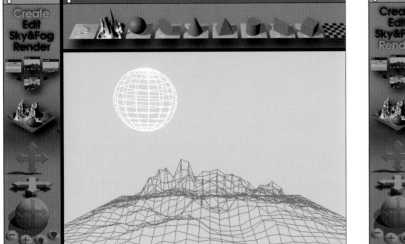

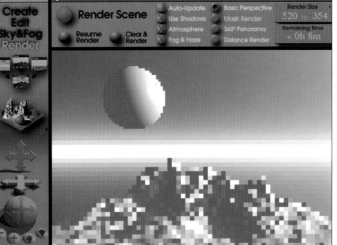

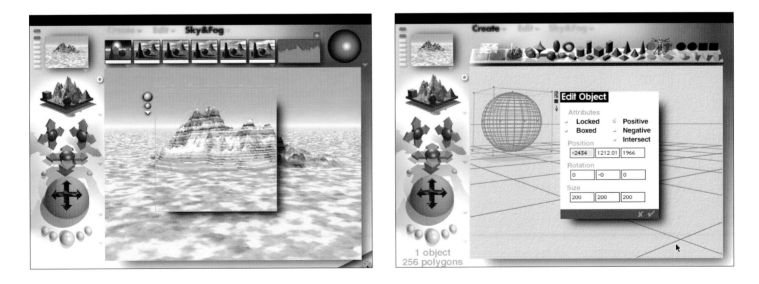

EDUCATIONAL/REFERENCE

Nile: Passage to Egypt starts aboard a *felucca*, an ancient boat, used as the main navigational vessel for exploring the CD-ROM. The designers creatively incorporate the remaining navigation and learning elements into the prow of the *felucca*: a camera for taking pictures on the journey, a journal, compass, map, video viewer, and a magic lamp. Each of these items comprise a creatively designed interface that allows further exploration and game playing. The interactivity, games, 3-D animation, and stylized art all work together to create a beautiful, enjoyable, and educational interactive.

To fully engage the user, the designers created text editors, so that those who take the journey can keep a journal. Taking a snapshot with the camera sends a virtual photo directly into the journal for later viewing, while at the same time adding text about the object photographed.

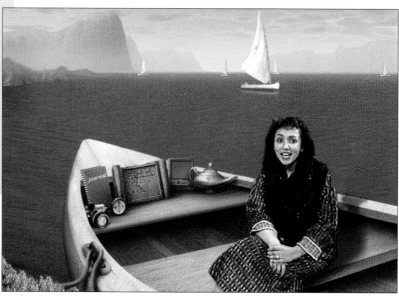

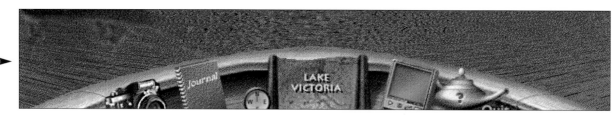

Project: *Nile: Passage to Egypt*
Client: **Discovery Channel Multimedia**
Design Firm: **Human Code, Inc.**
Designer: **Kyle Anderson**
Illustrators: **Maria Vidal, Chris Mead, Charles Furlong**
Photographers: **Saba Press, Thomas Hartwell,
McKinnon Films, Michael McKinnon**
Programmer: **Brian Brantner**
Producer: **Lloyd Walker**
Audio Producer: **John Malcolm Smith**
Music Composition: **Mark Connelly Wilson**
Asst. Producer/Digital Video Prod: **Mary Flanagan**
Authoring Program: **Macromedia Director**
Platform: **Mac/Windows**

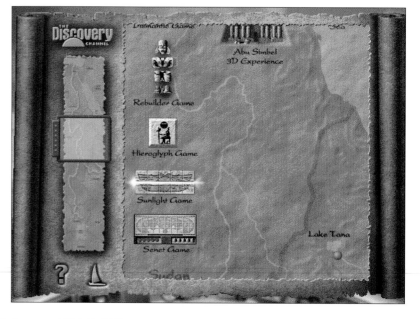

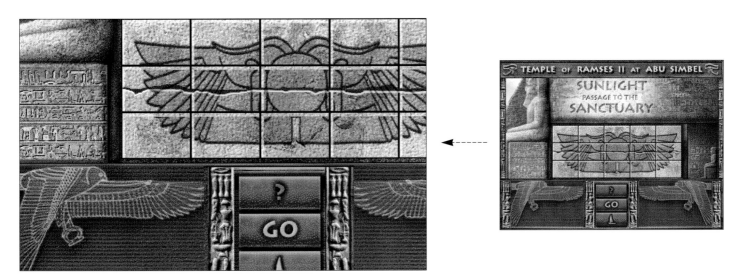

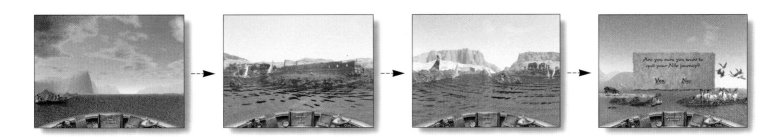

Floppy Disks:

Someone once told me that good design rests on following a few simple rules, the most important being "less is more." In designing projects intended for floppy diskette or online distribution, this could be restated as "less is mandatory." Floppy-based design offers a challenge in elegance and simplicity, both at the design and underlying interactive programming levels.

•

Creating multimedia projects that perform well—yet fit in the confined space of the standard 1.4-MB floppy disk—is an art form. The design needs to be compact from the start, as it wastes effort to create a beautiful piece too large to fit without being hacked apart. An interface designer must remember that every graphic takes precious disk space, and every "click" sound that plays when a button is pressed is one less piece of your message that the disk takes to the viewer. Often, the run-time player that provides the presentation the ability to turn itself on and play doesn't leave much room on the disk for actual content.

•

With good design sense and a basic understanding of graphics-compression formats, a designer can fit a surprising amount on a floppy disk, creating an easy-to-use interface and a memorable interactive experience. By using white space creatively and recycling graphic elements, a designer can make a gallery of rich artwork appear to dance on the head of a pin. With the right programming, an audience can be dazzled without video. By using the right sound at the right time, the interactive experience can seem as if it came from the expanse of a CD-ROM and not the confines of a floppy disk.

•

One good way to increase the storage capacity of a floppy is to use compression to make a large file fit on a disk that, uncompressed, would not fit. A compression pro-

gram allows almost twice the data to be stored on the disk, sometimes even more. The downside to this is that the viewer now has to go though the slightly annoying process of installing the program, instead of running straight from the disk. Compression is standard on the Internet, where download time is precious.

•

The real strength of the floppy is that it empowers all users to publish their own media. It's entirely possible to design, produce and distribute solely on floppies, practically for free. The floppy is a great tool for the guerrilla marketer who can customize each disk to suit the needs of each client, in a much more personal way than a mass-produced, immutable CD-ROM. Placing a portfolio on floppy rather than pressing a CD-ROM is also a great way to ensure that viewers aren't overloaded with more material than they may have the time or inclination to look at.

•

With the advent of the Iomega Zip drive and desktop CD-ROM burners, the age of the floppy is coming to an end. But that end isn't exactly right around the corner; every computer, whether Mac or PC, is shipped with an internal 3.5-inch floppy drive, and some PCs are even shipped with archaic 5.25-inch floppy drives. Though the floppy medium is waning, the Internet is becoming an increasingly important area for small, interactive demos and catalogs of 2MB or less.

•

For a small glimpse of this future, look at where the Web is today. Tools like Macromedia Shockwave and Sun's HotJava are giving us a taste for small downloadable media hits. As soon as the pipes become large enough, developers will be able to repurpose existing floppy sized presentations and will start distributing the "floppies" via the internet, the only difference being that you won't have to insert the disk.

Don Synstelien
Synstelien Design

DIGITAL PRESS KIT

Lollapalooza—the 1994 summer concert tour of alternative-rock musicians—was promoted with this interactive press kit for Warner Bros. To capture the feel of the music, Media Logic used bright colors accompanied by constantly moving images and animated type treatments.

Media Logic answered the constraints of floppy disk and download design by using low-resolution images and carefully compressed sound. The design firm made less seem like more by keeping the sound volume high, thereby reproducing the feel of the Lollapalooza tour.

Perhaps the most memorable segment is Green Day's Mad Bomber game; the game is played by dragging the Dookie characters (a wiener dog, monkey, or Elvis) onto the Green Day field, and dropping bombs on the characters. A successful hit results in a resounding "Kablooie" noise. Though the action is deceptively simple, the programming involved to create the game is elaborate and detailed.

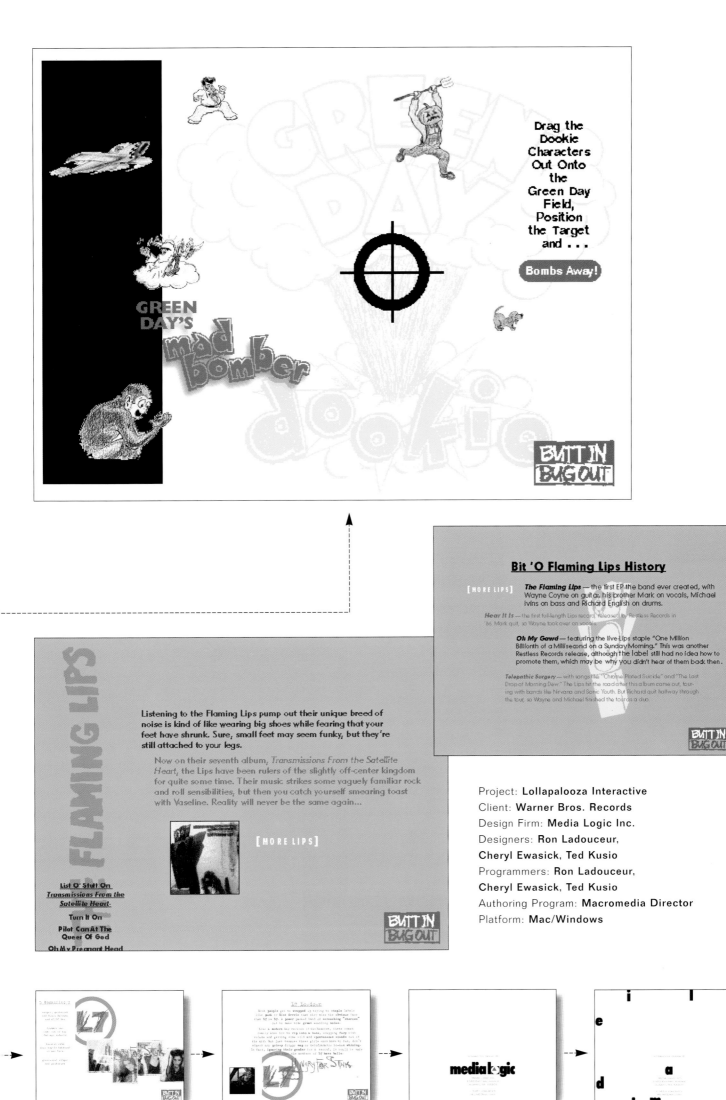

Drag the Dookie Characters Out Onto the Green Day Field, Position the Target and . . .

Bombs Away!

GREEN DAY'S mad bomber dookie

BUTT IN BUG OUT

Bit 'O Flaming Lips History

[MORE LIPS] *The Flaming Lips* — the first EP the band ever created, with Wayne Coyne on guitar, his brother Mark on vocals, Michael Ivins on bass and Richard English on drums.

Hear It Is — the first full-length Lips record, released by Restless Records in '86. Mark quit, so Wayne took over on vocals.

Oh My Gawd — featuring the live-Lips staple "One Million Billionth of a Millisecond on a Sunday Morning." This was another Restless Records release, although the label still had no idea how to promote them, which may be why you didn't hear of them back then.

Telepathic Surgery — with songs like "Chrome-Plated Suicide" and "The Last Drop of Morning Dew." The Lips hit the road after this album came out, touring with bands like Nirvana and Sonic Youth. But Richard quit halfway through the tour, so Wayne and Michael finished the tour as a duo.

BUTT IN BUG OUT

FLAMING LIPS

Listening to the Flaming Lips pump out their unique breed of noise is kind of like wearing big shoes while fearing that your feet have shrunk. Sure, small feet may seem funky, but they're still attached to your legs.

Now on their seventh album, *Transmissions From the Satellite Heart*, the Lips have been rulers of the slightly off-center kingdom for quite some time. Their music strikes some vaguely familiar rock and roll sensibilities, but then you catch yourself smearing toast with Vaseline. Reality will never be the same again...

[MORE LIPS]

List O' Stuff On Transmissions From the Satellite Heart:

Turn It On

Pilot Can At The Queer Of God

Oh My Pregnant Head

BUTT IN BUG OUT

Project: **Lollapalooza Interactive**
Client: **Warner Bros. Records**
Design Firm: **Media Logic Inc.**
Designers: **Ron Ladouceur,**
Cheryl Ewasick, Ted Kusio
Programmers: **Ron Ladouceur,**
Cheryl Ewasick, Ted Kusio
Authoring Program: **Macromedia Director**
Platform: **Mac/Windows**

DIGITAL PRESS KIT

Mary Chapin Carpenter's floppy disk-based multimedia presentation from Eagle River Interactive features an elegant interface that premieres music clips from the country singer's album, *Stones in the Road*. This promotional piece exhibits well-thought-out design elements, and shows how a small amount of content can be artistically presented.

Designed as a promotional piece for the record company, the software allows the user to open an animated audio-CD case and strum floating guitar strings with the cursor. A cursor rollover produces four distinctive notes; when the strings are clicked, the user is led to another screen where a brief musical clip from the album plays. Exiting the presentation reverses the animation, and the CD case closes.

Project: **Mary Chapin Carpenter/*Stones in the Road***
Client: **Sony Music**
Design Firm: **Eagle River Interactive**
Designers: **Staff**
Authoring Program: **Macromedia Director**
Platform: **Mac**

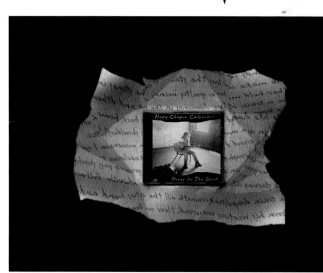

82

PROMOTIONAL PRESENTATION

B.C. 5209.0

A.D. 1406.6000

A.D. 1980.219

Eagle River Interactive's electronic business card shows the evolution of creative thought from the Stone Age, through the Renaissance, and into the Modern Era. It also serves as an effective promotional tool for the design firm.

To engage the user, the designers have incorporated distinctive background music and illustration to set the tone of each era. To advance to the next era the user must correctly choose three of the five icons that represent the key creative tools for that era, such as the hand, chisel and stone shown in the top screen for the Stone Age era.

After the user has chosen the correct three icons, the pieces animate and a quote appears explaining that the objects chosen, when placed in the hands of creative thinkers, changed history profoundly. The blend of animated icons, music, text, and illustration create an entertaining and memorable presentation.

Project: *Electronic Business Card*
Design Firm: **Eagle River Interactive**
Designers: **Staff**
Authoring Program: **Macromedia Director**
Platform: **Mac**

DIGITAL PORTFOLIO

imedia's portfolio beckons users to navigate around a virtual office. The interface comprises 3-D objects such as a note on the door, a telephone, and a printer. Clicking on these objects reveals background information about the company. In a creative display of interactivity, almost all the objects in the office are either functional or entertaining. For instance, clicking on a videotape, floppy disk or CD-ROM activates the relevant playback device complete with lights and sound, which then displays more information about the company. On the whimsical side, clicking on an electrical outlet produces sparks accompanied by crackling. Clicking on the plant changes the cursor from a hand to a watering can.

Cursor transformation is used to signal important information to the user. Instead of offering the user an obvious exit button, the exit option is signaled when the cursor changes from a hand to an open door. This change occurs when the cursor rolls over the large picture window in the office. The virtual environment is also enhanced and softened by the extremely well-crafted lighting effects.

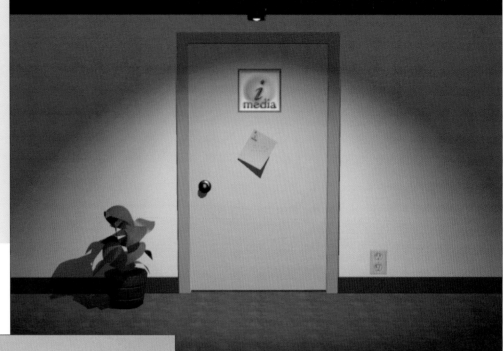

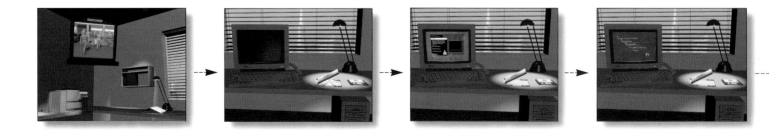

Project: *imedia Studio Tour*
Design Firm: imedia Interactive Multimedia
Designers: B. Almashie, H. Campos
Illustrators: B. Almashie, H. Campos
Programmers: B. Almashie, H. Campos
Authoring Program: Authorware
Platform: Mac/Windows

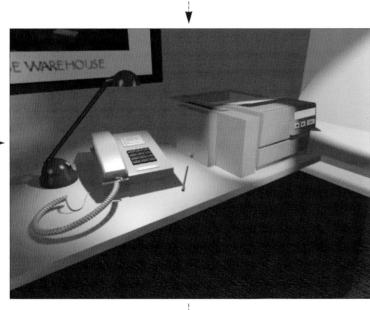

DIGITAL PORTFOLIOS

WOW Sight + Sound designed these three photography portfolios around the principle that end use determines the success or failure of interactive media products. Each promotional piece was designed to reflect the photographer's visual style and to provide an innovative environment for the photographer's work.

The portfolio for MTV photographer Frank Micelotta begins with a lively opening sequence, then segues into a palette bar displaying a montage of the photographer's images. The interface palette offers three ways of viewing the photographer's work: clicking on the palette brings up a specific image; dragging an image from the palette to the interface desktop; or using the forward/backward arrows to view each image consecutively. Appropriate sound bites accompany each image as it appears on the screen, and a magnifying glass is supplied for viewing larger images.

* * *

The design of Joyce Tenneson's portfolio takes a different approach in presenting the photographer's work. During the opening sequence the photographer discusses her style and reminisces about her work, while photos from the portfolio fade in and out.

The portfolio is characterized by extreme simplicity and elegance, aptly reflecting the photographer's work—each photograph is displayed by clicking on its thumbnail image located in a row across the bottom of the screen.

* * *

The designers at WOW developed yet another navigational device for Michel Tcherevkoff's portfolio. The opening features an animated slide show accompanied by moving type and a jazzy, upbeat sound loop.

As with Joyce Tenneson's portfolio, the interface is clean and simple. The user traces a line of curved text ("Naked, you are simple as a hand...") with the cursor to reveal the portfolio images.

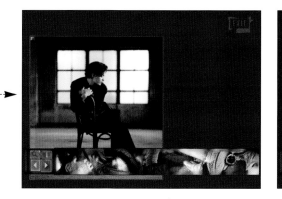
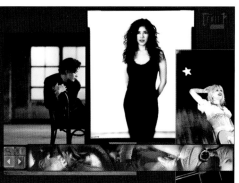

Project: **Photographer's Portfolio**
Client: **Frank Micelotta**
Photography: © **Frank Micelotta**
Design Firm: **WOW Sight + Sound**
Designers: **Abby Mufson,**
Darell Dingerson, John Fezzuoglio
Programmers: **Darell Dingerson**
Platform: **Mac**

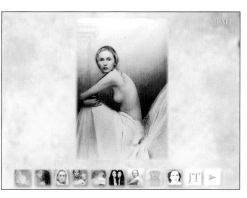

Project: **Photographer's Portfolio**
Client: **Joyce Tenneson**
Photgraphy: © **Joyce Tenneson**
Design Firm: **WOW Sight + Sound**
Designers: **Abby Mufson,**
John Fezzuoglio
Programmers: **Abby Mufson,**
Darell Dingerson
Platform: **Mac**

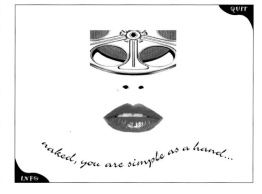

Project: **Photographer's Portfolio**
Client: **Michel Tcherevkoff**
Photography: © **Michel Tcherevkoff**
Design Firm: **WOW Sight + Sound**
Designers: **Abby Mufson, Alec Cove**
Programmers: **Abby Mufson, Alec Cove**
Platform: **Mac**

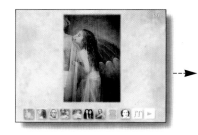
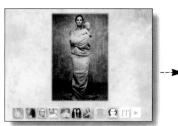

DIGITAL PORTFOLIO

Jack Harris' portfolio piece takes a familiar interface—the childhood game of Operation—and turns it into a navigation device. With this interface the designer has had to do very little in the way of instruction in the use of the interface, and has let the familiar game concept carry the weight—making accessing and navigating the interface easy for even the novice user.

Similar to the American board game of Operation, the user moves the cursor over the icons located around the body, and then clicks on each one to go to the next screen. Rolling the cursor over the image of the computer chip brings up the phrase "chip on the shoulder" in the text box. Clicking on the image then takes the user to the full portfolio piece.

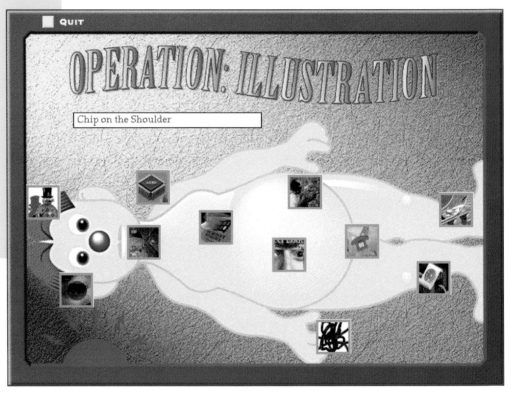

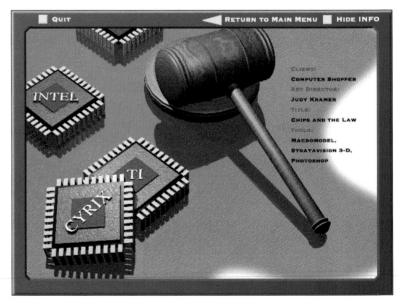

Project: *Diskfolio 2: Operation Illustration*
Design Firm: **Visual Logic**
Designer: **Jack Harris**
Illustrator: **Jack Harris**
Programmers: **Jack Harris, Katie Houghton**
Authoring Program: **Macromedia Director**
Platform: **Mac**

 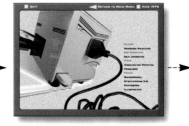 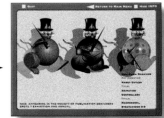

fontBoy's interactive catalog does one thing well that all font designers need: it gets the company's fonts seen. To achieve this end, designers Aufuldish & Warinner created several display pieces for their fonts. The fontBoy interactive catalog allows the user to view samples of fonts, print bitmapped samples of fonts, get ordering information, and find out about future releases, all within a designer-friendly environment.

In the main holding screen, letterforms float randomly in space. When the mouse passes over a letter, the letter stops moving, and the name of the font appears. Double-clicking on the letter takes the viewer to a screen that displays the full font family. This controlled chaos looks great; for the impatient, however, a directory is provided for easy access to individual fonts.

Project: **fontBoy Interactive Catalog**
Client: **fontBoy**
Design Firm: **Aufuldish & Warinner**
Designer: **Bob Aufuldish**
Programmer: **Dave Granvold**
Writer: **Mark Bartlett**
Sound Design: **Scott Pickering, Bob Aufuldish**
Authoring Program: **Macromedia Director**
Platform: **Mac**

MULTIMEDIA DESIGNER

Lawrence Becker understands that, as the competition for multimedia jobs gets tougher, designers need to expand their methods of approaching potential employers and clients. He has addressed this issue with his diskette presentation. InfoPad, his high-tech resume and portfolio—when compressed—fits on a single floppy, allowing Becker to easily distribute his portfolio through the mail and online services.

The opening sequence of the resume holds the user's attention as the InfoPad transforms from a wireframe model to a solid, rendered 3-D image. The InfoPad reacts as if it were a real piece of equipment: after turning it on, the user must wait for it to start up before continuing.

Other elements such as illuminated buttons and realistic lighting give the project a sense of realism, and display an attention to detail that a simple interface benefits from.

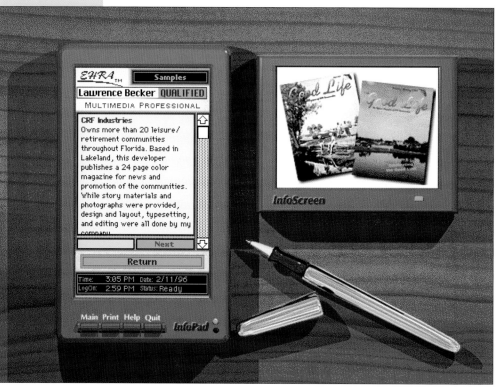

Project: **Multimedia Resume**
Design Firm: **The Becker Group**
Designer: **Larry Becker**
Authoring Program: **Macromedia Director**
Platform: **Mac**

David Ciske's desktop blotter displays his combined talents as an illustrator and multimedia designer. The blotter comes cluttered with postcards that serve as the interface for navigating his resume and portfolio, but the key element of this resume is the yellow Post-It used as a navigational button. This device not only makes exploring the interface easy, but also shows that the designer has a sense of humor.

The additional elements of layered postcards used to exhibit the designer's portfolio make updating the resume easy: postcards can be added, replaced or deleted as needed.

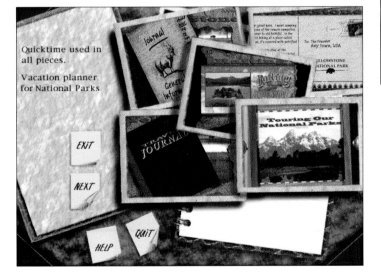

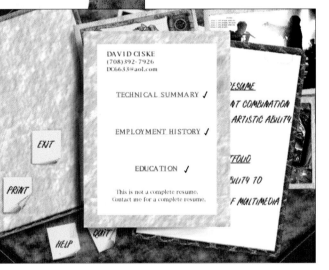

Project: **Interactive Resume**
Design Firm: **David Ciske**
Designer: **David Ciske**
Authoring Program: **Macromedia Director**
Platform: **Mac**

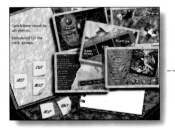
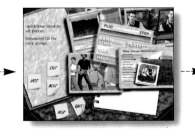
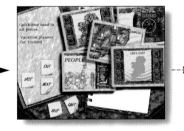
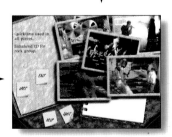

MULTIMEDIA DESIGNER

Joe Mack, a freelance multimedia designer, created a digital resume and portfolio that offers a number of entertaining elements that work together to keep the user interested in exploring his portfolio.

The flat, one-dimensional feel of a newspaper's help-wanted pages contrasts nicely with JobSeek's high-tech, 3-D rendered surfaces, while glowing green buttons, and the continuously rotating icon on the contents screen evokes the look and feel of a working piece of digital equipment.

Within the portfolio, the user experiences 3-D animations, sound, and more of Joe Mack's 3-D illustration and design. All of these elements combine to create a high-quality interactive piece that compresses to fit on a single floppy disk.

Project: *Joe Mack's JobSeek Interactive*
Design Firm: **Multi-Mac-Media**
Designer: **Joe Mack**
Authoring Program: **Macromedia Director**
Platform: **Mac**

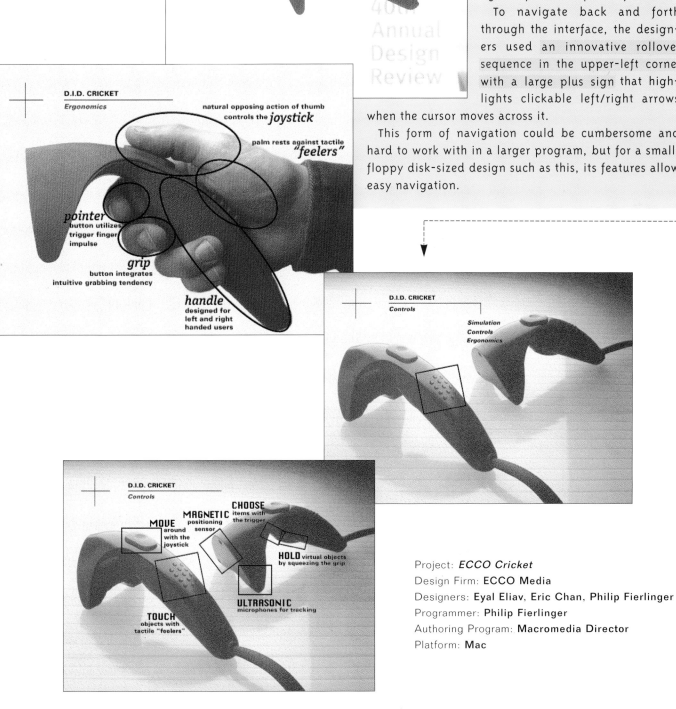

ECCO's *Cricket* design project has no visible buttons for content navigation. The interface is designed so that rollovers reveal hierarchical indexes that light up when activated by the cursor. The text in these indexes leads to other screens in the presentation, where rollovers again are used to highlight important aspects of *Cricket*.

To navigate back and forth through the interface, the designers used an innovative rollover sequence in the upper-left corner with a large plus sign that highlights clickable left/right arrows when the cursor moves across it.

This form of navigation could be cumbersome and hard to work with in a larger program, but for a small, floppy disk-sized design such as this, its features allow easy navigation.

Project: *ECCO Cricket*
Design Firm: **ECCO Media**
Designers: **Eyal Eliav, Eric Chan, Philip Fierlinger**
Programmer: **Philip Fierlinger**
Authoring Program: **Macromedia Director**
Platform: **Mac**

DIGITAL MAGAZINE

@Type.New is a high-quality, artfully designed digital typography magazine produced by font designer Don Synstelien. The magazine offers typographers and designers an outlet for displaying their fonts, and creates a forum for discussion of typographical issues.

@Type.New is accompanied by an unobtrusive synthesized sound loop, but the most striking aspect of *@Type.New* is its predominantly black-and-white interface. White buttons with blurred drop shadows are used throughout, creating a visually appealing design with depth.

Project: **@Type.New**
Client: **Font Magazine**
Design Firm: **Synstelien Design**
Designer: **Don Synstelien**
Authoring Program: **Macromedia Director**
Platform: **Mac**

Ginny Westcott's interactive portfolio and resume shows that working knowledge of a multimedia program such as Macromedia's Director—combined with creativity and high-quality design skills—produces a very satisfying interactive experience.

The Matisse-like cut paper images used as buttons clearly illustrate the main components of the resume; primary colors elicit a sense of vibrancy and directness in the piece, and at the same time keep the file size small enough to fit on a floppy disk.

Project: **Interactive Resume and Portfolio**
Design Firm: **Ginny Westcott**
Designer: **Ginny Westcott**
Authoring Program: **Macromedia Director**
Platform: **Mac**

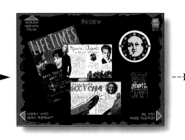

DIGITAL BROCHURE

The Emigre type foundry needed a floppy disk-sized promotional piece to distribute over their *Now Serving* bulletin board service and promote the ZeitGuys font. Because the download time needed to be kept as short as possible, bitmapped images created from the font comprise the majority of the brochure.

The introduction opens with an animated type treatment, then segues into a looped slide show of the ZeitGuys font, accompanied by a sound file that loops until the user clicks to go to another screen.

The *ZeitMovie* makes use of minimal interactivity, needing only a "forward" and "backward" button to navigate the main interface.

Once in the main interface, dynamic screen action in the form of constantly shifting images from the font keeps the user engaged. The components of this piece—fonts, sound bites and animated sequences—work well to emphasize the quirky, irreverent nature of the ZeitGuys font.

Project: *ZeitMovie*
Client: **Emigre**
Design Firm: **Aufuldish & Warriner**
Designer: **Bob Aufuldish**
Writer: **Mark Bartlett**
Sound: **Scott Pickering, Bob Aufuldish**
Icons: **Eric Donelan, Bob Aufuldish**
Programmer: **Bob Aufuldish**
Authoring Program: **Macromedia Director**
Platform: **Mac**

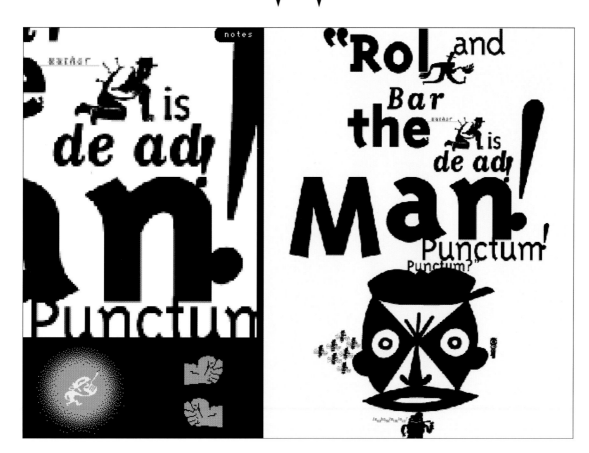

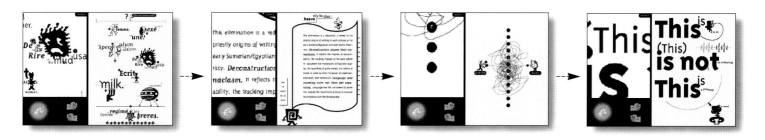

DIGITAL BROCHURE

The *Zion Canyon: Treasure of the Gods* interactive brochure captures the essence of what a digital brochure should be. The presentation begins with a dramatic Native American voiceover speaking words as they appear on screen, using an eagle's screech and fly-by to segue into slider bars that act as buttons for navigating the different eras of Zion's history.

An animated type treatment on each of the five main screens holds the user's attention, aided by the consistent, balanced use of icons, music, and photography to convey a Southwestern United States feel.

Zion ends on a humorous note, as a lizard icon devours the company's spinning logo with a satisfying burp when the user clicks to exit the program.

Project: *Zion Canyon: Treasure of the Gods*
Client: **World Cinemax Productions Inc.**
Design Firm: **Alliance Interactive Media**
Designers: **Christian Memmott, Rocky Campbell, Brian Curtis, Daniel Lee**
Authoring Program: **Macromedia Director**
Platform: **Mac**

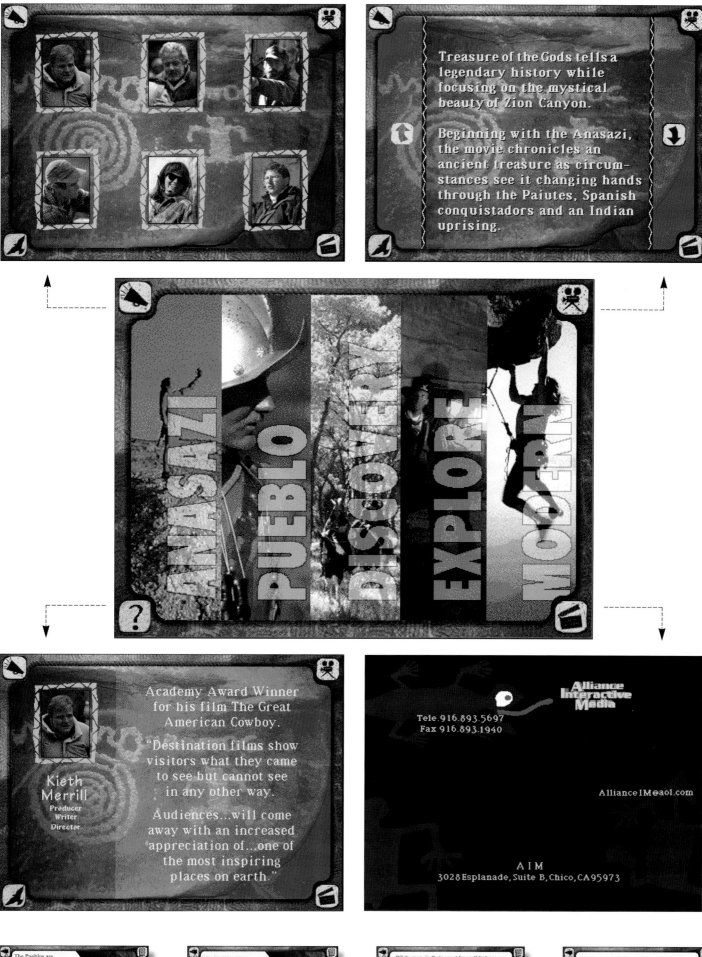

Treasure of the Gods tells a legendary history while focusing on the mystical beauty of Zion Canyon.

Beginning with the Anasazi, the movie chronicles an ancient treasure as circumstances see it changing hands through the Paiutes, Spanish conquistadors and an Indian uprising.

ANASAZI PUEBLO DISCOVERY EXPLORE MODERN

Academy Award Winner for his film The Great American Cowboy.

"Destination films show visitors what they came to see but cannot see in any other way.

Audiences...will come away with an increased appreciation of...one of the most inspiring places on earth."

Kieth Merrill
Producer
Writer
Director

Alliance Interactive Media

Tele. 916.893.5697
Fax 916.893.1940

AllianceIM@aol.com

AIM
3028 Esplanade, Suite B, Chico, CA 95973

The Pueblos are considered by some to be the remnants of the Anasazi. Around 1680, the Pueblos were enslaved by Spanish conquistadors. Under the whip of their Spanish masters, the Indians dug the gold, which was sorted, poured, and stamped into ingots. Throughout the Southwest, the Ceremony of the Knot is performed. Untying a single knot each day, Pueblo slaves counted time on their strings of yucca fiber until the hour of revolt.

White men, in their quest for earthly treasures and heavenly souls, continue to pass by this place... "the center of the earth"...For three quarters of a century, not knowing it is there. When finally they "find" it, like so much of Mother Earth, they claim it as their own...and give it a new name. "Zion"... a place of peace, harmony, and devotion to their God.

MULTIMEDIA DESIGNER

Don Synstelien's resume, font catalog, and portfolio comes distributed on two floppy diskettes. It offers an entertaining look at the designer, along with a uniquely designed tour of his work: by providing unique interfaces to navigate each area, the designer proves his skills in creating original and engaging multimedia designs.

The main interface for navigation is the designer's wallet, packed full of clickable objects. The diskettes take the user to an interactive font catalog, displaying fonts created by Synstelien. This catalog offers an interesting mix of environmental and synthesized sounds for background music, while half-round buttons work as rollovers that light up to show ready-to-buy fonts.

On the right side of the wallet is a small, 3-D portfolio, which opens to a larger rendering of the image. This area of the portfolio is used to show prospective clients and employers the designer's illustration and 3-D design capabilities.

hmm, a wallet. I won...

cool, some disks....

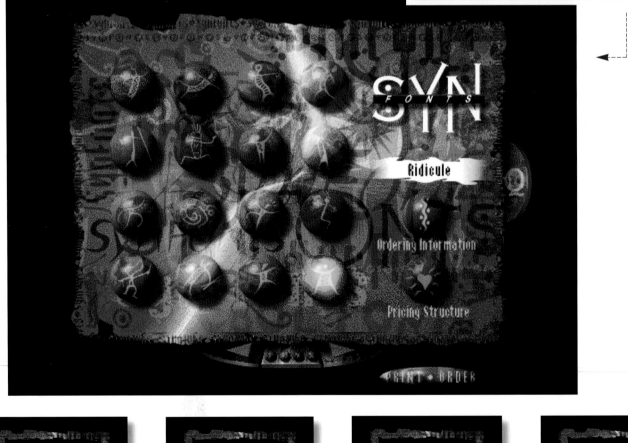

electric weasel

BRAN MUFUN

Omaha
Ultralight•Extralight•Regular•Bold

Guilty

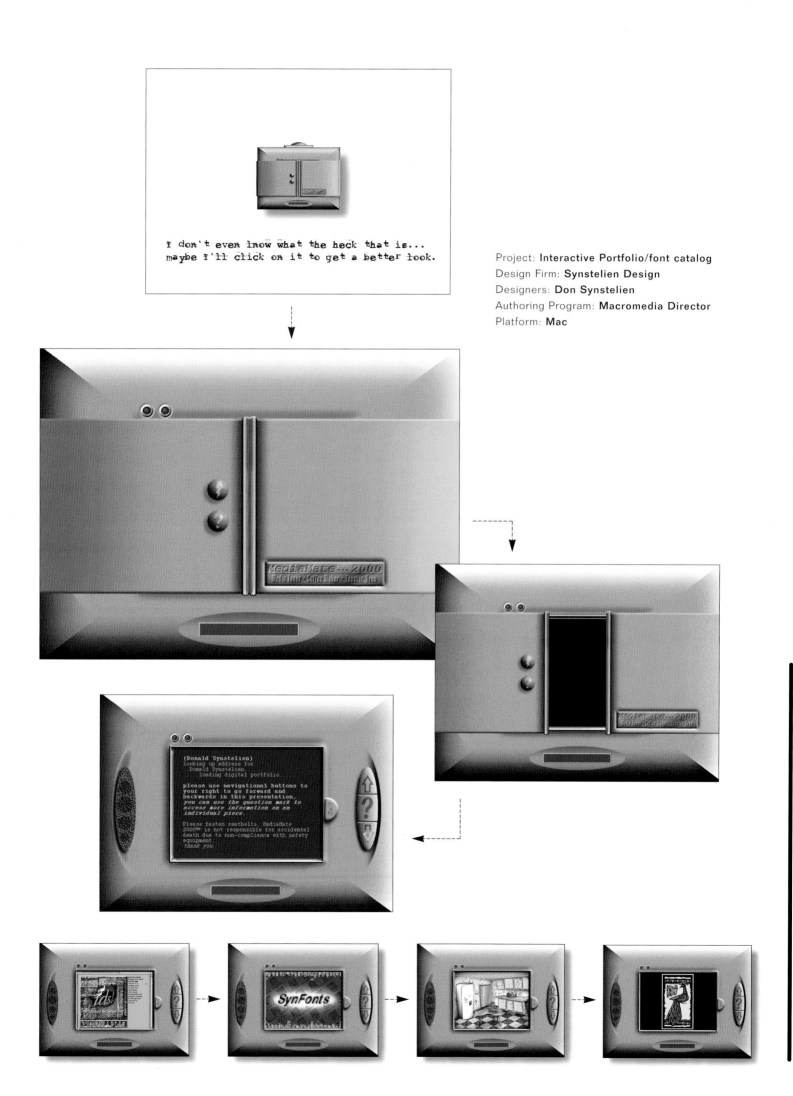

Project: **Interactive Portfolio/font catalog**
Design Firm: **Synstelien Design**
Designers: **Don Synstelien**
Authoring Program: **Macromedia Director**
Platform: **Mac**

PROMOTIONAL PRESENTATION

Eagle River Interactive's CD-ROM portfolio features these two interactive promotional pieces, which originally appeared on floppy disk. The *Baker Electronic Business Card* was created to showcase the work of Baker Audio/Telecom, which produces kiosks, point of sale displays, and data control systems. A unique and imaginative opening sequence presents the user with animated blueprints displaying the various designs and work Baker has produced.

Another device that the Eagle River designers created for this is the "Cool Tool," a draggable window that reveals a rendered 3-D image as it passes over the blueprint of a project.

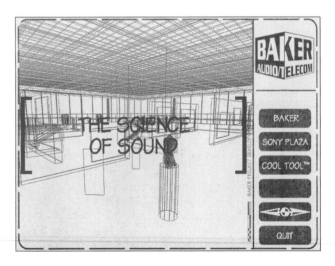

Project: *Baker Electronic Business Card*
Client: **Baker Audio Telecom**
Design Firm: **Eagle River Interactive**
Designers: **Staff**
Authoring Program: **Macromedia Director**
Platform: **Mac**

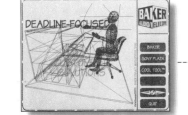

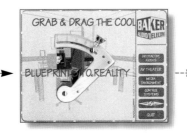

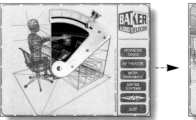

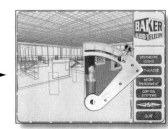

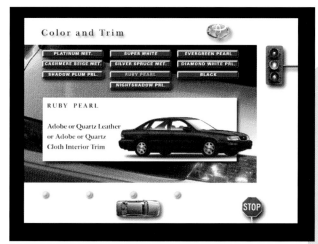

Toyota needed a floppy disk-based brochure to promote its new flagship car, the Avalon. Eagle River was in the process of producing a full CD-ROM for Toyota when the manufacturer launched the new model, and asked the firm to create the Avalon brochure, which it accomplished by repurposing artwork from the CD-ROM.

The interface for the brochure uses several entertaining elements for navigation: a stoplight serves as the forward, pause and return buttons, and a miniature Avalon is used as a slider button to browse other areas of the interface. For an exit button, the designers incorporated a stop sign at the bottom of each screen.

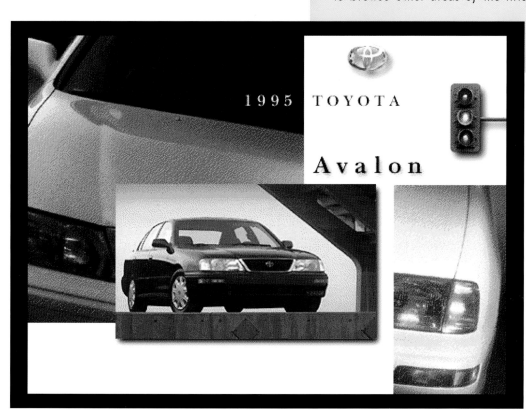

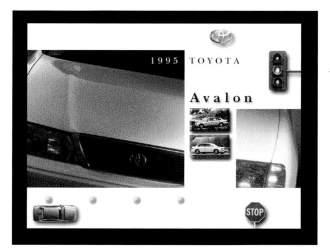

Project: **Toyota Promotion**
Client: **Toyota**
Design Firm: **Eagle River Interactive**
Designers: **Staff**
Authoring Program: **Macromedia Director**
Platform: **Mac**

DIGITAL PORTFOLIO

Ribit Productions Inc.'s portfolio is simple in design, yet extremely effective in capturing the attention of the user.

The piece opens with a parody of da Vinci's familiar "Diagram of Man" sketch in the form of a frog, which morphs into a more realistic frog rendering before jumping off screen and into the company's logo. The software gives a quick overview of the important strengths of the design firm—a wise strategy to follow, considering the time constraints of many potential clients.

The designers have created a warm and enjoyable portfolio without the mechanical coldness of buttons and hard edges that characterize many other portfolios; the navigational bar at the bottom of the screen is composed of four da Vinci sketches that, when clicked, take the user to four different examples of the company's work.

Project: **Digital Portfolio**
Design Firm: **Ribit Productions Inc.**
Designers: **Ronda Bailey, Sean Wu**
Illustration: **Ronda Bailey, Sean Wu,**
Scott Lumley
Programmers: **Ronda Bailey, Sean Wu,**
Mindy Miller
Authoring Program: **Macromedia Director**
Platform: **Mac**

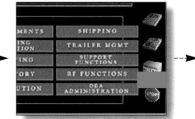

Roberta Woods' portfolio exemplifies the idea that an interface need not be intricate and involved in order to be effective. Her rich illustrations, beginning with the texturally illustrated main screen, create a consistent look and feel throughout the presentation.

The colors and lighting used on the main screen complement the smaller icons in the center. Clicking on these icons brings up a larger image of the original work, and though it takes only a few minutes to navigate the presentation, the illustrations are sure to compel the viewer to experience them again.

Project: **Interactive Portfolio**
Design Firm: **Roberta Woods Design & Illustration**
Designer: **Roberta Woods**
Interface Design: **Stirling H. Alexander**
Authoring Program: **Macromedia Director**
Platform: **Mac**

DIGITAL PROMOTION

PPM& (LifeLines) is elegant in its simplicity. The interface is simple, with a row of navigable buttons running along the bottom of the screen, scrolling text, and photos that change when clicked upon. This design stands apart from others in its subtle use of colors and the use of a hummingbird (with flapping wings) as a cursor.

Moving the hummingbird from left to right switches the direction of the bird, and clicking on a button sends you to another screen accompanied by a trilling bird song.

Peter, Paul & Mary, the legendary trio that celebrates its 35th anniversary this year, announces the April 11 release of PP M&: LifeLines (Warner Brothers Records), an album unlike any they've recorded before.

Peter, Paul and Mary in collaboration with Judy Collins, B.B. King, Carly Simon, Lucy Simon, Emmylou Harris, Ramblin' Jack Elliot, John Gorka, Richie Havens, Holly Near, Tom Paxton, John Sebastian and Pete Seeger celebrate the family of folk with their new album PPM& (Lifelines) produced by Phil Ramone for Warner Records

The Kid
Words and music by Buddy Mondlock
Lead vocals: Peter, Paul & Mary

Project: *PPM& (LifeLines)*
Client: **Warner Bros. Records**
Design Firm: **Post Tool Design**
Designers: **David Karam, Gigi Biederman**
Illustration: **David Karam, Gigi Biederman**
Authoring Program: **Macromedia Director**
Platform: **Mac/PC**

Project: **Faith No More:** *King For A Day/Fool For A Lifetime*
Client: **Warner Bros. Records**
Design Firm: **Post Tool Design**
Designers: **David Karam, Gigi Biederman**
Illustration: **Eric Drooker "Flood! A Novel in Pictures"**
Authoring Program: **Macromedia Director**
Platform: **Mac/PC**

DIGITAL PROMOTION

Faith No More's floppy disk-based promotion shows how technical and artistic elements are integral to Post Tool Design's interactive multimedia. In this project, the screens are layered with text and photos, and "graphic novel" style menu buttons at the bottom of every screen serve to unify the presentation.

The screens lead the viewer into an interactive playground that cannot be duplicated in any other medium. One screen is filled with pieces of art, text, and photos, which the viewer clears away by clicking on each piece in a "cleansing" process; another is blank until the viewer selects an image to draw with, creating his or her own ephemeral art.

DIGITAL PRESS KIT

The Soul Coughing interactive press kit shows Aufuldish & Warriner's solution to the great challenge of designing for the floppy disk medium: compression. Fitting as much information as possible onto a 1.4-MB floppy—while keeping the project interesting and entertaining—can be a real challenge.

The designers of this press kit have met this challenge by using 1-bit color graphics, allowing them to place many images in the project and use the space efficiently. Realistic photos are kept at a minimum and are used only at smaller sizes; larger images are manipulated to look good with limited color palettes. Optimizing palettes and using 1-bit images results in a rough, pixellated look, which the designers have used to their advantage for Soul Coughing. By keeping visual elements small, the designers avoid excessive compression of the sound files, which would result in distortion. This allows three songs from the album to be featured as sound loops, activated when the cursor is rolled over hotspots on the interface.

Three elements of the interface are particularly engaging: first, the use of constantly moving images—nothing is static, objects are always sliding, jittering or blinking on and off to the strong beat of Soul Coughing's music; second, draggable text blocks of song notes and concert dates invite user interaction with the interface; finally, each screen features hotspots where other imagery and animations are revealed when the cursor is passed over them.

Project: **Soul Coughing interactive press kit**
Client: **Warner Bros. Records**
Design Firm: **Aufuldish & Warinner**
Art Director: **Bob Aufuldish**
Art Director (Warner Bros. Records): **Kim Biggs**
Creative Director (Warner Bros. Records): **Jeri Heiden**
Programmer: **Bob Aufuldish**
Authoring Program: **Macromedia Director**
Platform: **Mac/Windows**

World Wide Web:

The realm of communication with which I am most familiar is a tiny universe of visual design expressed in branding, packaging, environmental graphics, print graphics, and advertising in general. Website design is a new entry in this visual universe, but the rules and directives haven't changed: *communication* is still the primary task of all these visual design forms.

•

Even with this fresh new medium, classic principles of marketing design apply: a marketing designer is charged with communicating a specific idea for a specific client, generating a specific consumer response. In Web design, an interface designer is charged with communicating a specific idea for a specific client to generate a specific consumer response. No coincidence. Most consumers/viewers just want to go in, get the message, and move on: it's a quick, simple process. Website designers run the risk of allowing high technology to get in the way of communication by overwhelming the viewer's senses with a daunting barrage of heavy content and complex operational procedures. Viewers should wish to revisit the Website because they feel emotionally drawn to return, not because they need another crack at digesting a voluminous blast of data.

•

The Website designer should not dwell on tools, computer equipment and software, but should reach beyond the tools to focus on visually memorable communication that challenges the market. It is not the tools that make the design enduring and effective (tools don't communicate), but the skill and sense of the person who wields them.

•

As mass market reality sets in on the Internet, high-level marketing design will become a competitive necessity that enables successful Websites to stand out from the clamoring crowd and entice repeat viewers. Through strong graphics, bold brand

design, and an emphatic brand identity, the Website should communicate a memorable message with the same directness and immediacy of a package on the supermarket shelf.

•

Internet consumers have a finite amount of time in which to visit a seemingly infinite number of Websites. These consumers are increasingly sophisticated, selective, and critical. Good interface design done well motivates viewers to respond, revisit, and get involved in the site; poor interface design deadens viewer interest in a site permanently. Second chances are rare—who has time to spend on bland, disappointing experiences?

•

But successful sites beware! The Website that succeeds in luring repeat viewers should not take the victory lightly and become lazy or static. I speak from experience: sites have to change and evolve to follow, match, and spur viewer interest and development. Once you've got the audience, respond to them and make them respond to you. Ask questions and elicit questions that touch their emotions and compel them to return.

•

Word spreads quickly over the electronic network: your brand builds a loyal following of consumers/viewers who direct others to your site, and the cycle continues, multiplies, and renews itself from there. This excitement, this emotional pull is the direct result of strong marketing communication. Producing and consuming this communication should be an unending, episodic adventure.

Primo Angeli
Primo Angeli, Inc.

MULTIMEDIA DESIGNER

Mya Kramer Design Group created an exciting and intuitive Web presence for the multimedia division of Autodesk—the maker of 3-D multimedia graphics products—with no significant previous experience in interactive Web design.

The opening page to the site depicts the mind of a multimedia designer with action words that invite the viewer to explore the pages and "experience creation," as the company's slogan goes.

Mya Kramer Design Group created the site with several objectives in mind and adhered to them strictly: the site had to allow visitors to go anywhere in three clicks or less; the downloading of a graphic could not take more than fifteen seconds; and the site had to be open and airy. All three of these objectives were accomplished. The pages within the Website download quickly, and make for an easily navigable and graphically pleasing site.

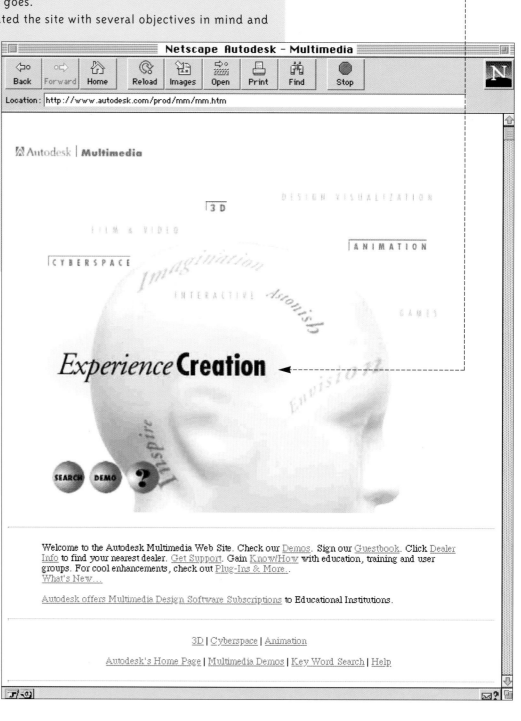

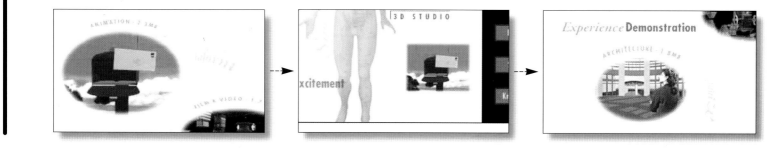

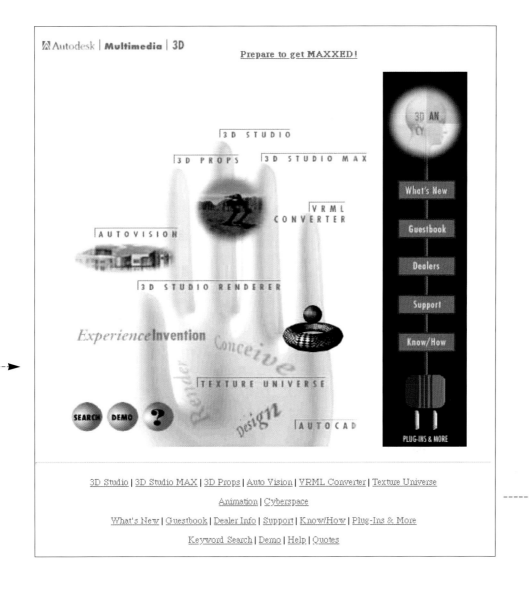

Project: **Autodesk Website**
Client: **Autodesk, Inc.**
Design Firm: **Mya Kramer Design Group**
Designers: **Mya Kramer, Amy Suits**
Programmers: **Gavin Bridgeman,**
John Kuta, Bryan Holland
Photographer: **Robert Cardin**
Authoring Program: **HTML**
Platform: **Browser Related**
URL: **http://www.autodesk.com/prod/mm/mm.htm**

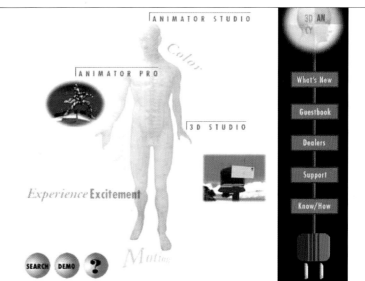

ONLINE MAGAZINE

HotWired has become one of the hottest, fastest-growing Web magazines. *HotWired* set a standard for Web publishing; both design and content are specific to the online version, developed entirely with the medium in mind. In keeping with the design of the print version of its print-magazine counterpart *Wired, HotWired's* success stems from the publisher's ability to respond to the readers accessing the Web magazine.

HotWired's first interface design incorporated large graphics, considered by many users to take too much download time. *HotWired's* second interface, shown here, uses smaller illustrations and generous white space for maximum throughput and faster accessibility.

The bold icon designs that *HotWired* uses for section headings offer Web users a colorful, visually appealing interface. More importantly, they offer a fast download, because they use a limited color palette. *Hotwired's* designers worked closely with illustrator Max Kisman to create images that avoided using 8-bit color, instead focusing on 2- and 4-bit color images when possible.

Netscape: HotWired: Overview

What's New? | What's Cool? | Handbook | Net Search | Net Directory | Newsgroups

HOTWIRED

SIGNAL

Flux
Fetish
Net Surf
Net Soup
DaveNet
BBF!!!
Market
Forces
Muckraker
Intelligent

WORLD BEAT

On the Road
Planet Wired
Deductible
Junkets

PIAZZA

Club Wired
HotMoo
Rants &
Raves
Threads

RENAIS-SANCE 2.0

Retina
Kino
Soundz
Twain
Serial

COIN

Uncommon
Market
Window
Shopping
Library
Sponsors

WIRED

Back Issues
Subscribe
WiredWare
Privacy
Archive

Project: *HotWired* **Website**
Client: *HotWired* **Magazine**
Design Firm: **Plunkett + Kuhr**
Designers: **John Plunkett, Barbara Kuhr**
Illustrator: **Max Kisman**
Authoring Program: **HTML**
Platform: **Browser Related**
URL: **http://www.hotwired.com**

PROMOTIONAL PRESENTATION

Macromedia's Website should be bookmarked in every multimedia designer's browser, especially now that the Shockwave plug-in, which works with Netscape to play Macromedia Director animations, is available. With its wealth of information, coupled with an attractive interface, this site is helping set the course for future multimedia design.

The intro screen to Macromedia's contents page uses the Shockwave plug-in to create a slot-machine-like effect (including sound) as images roll into place. The "hot contents" button then cycles through an animation of a flame until the viewer clicks to go to the main contents page.

The designers of Macromedia's site have done an exceptional job of combining an extensive data-base of information with a graphical interface. Icons identify all of the main sections and are repeated on subsequent links, and each section is color-coded to facilitate navigating the site.

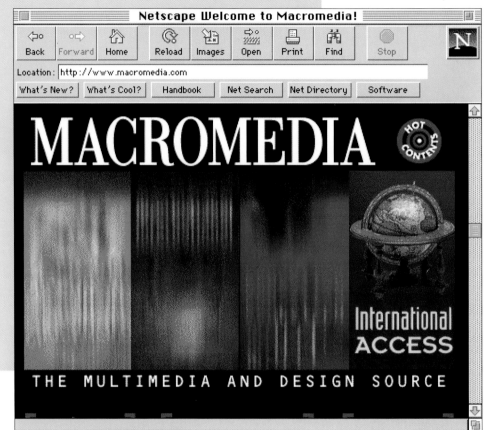

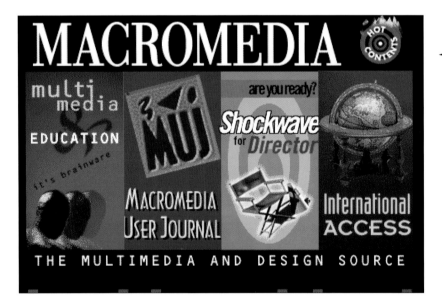

Project: **Macromedia Website**
Design Firm: **Macromedia**
Designers: **Macromedia Staff**
Authoring Program: **HTML**
Platform: **Browser Related**
URL: **http://www.macromedia.com**

Copyright © Macromedia, Inc. 1995. Used with permission.

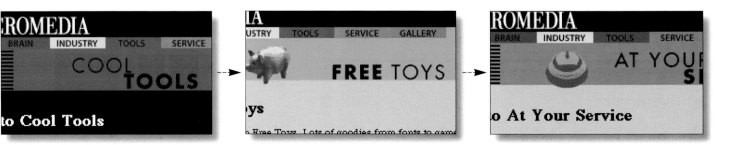

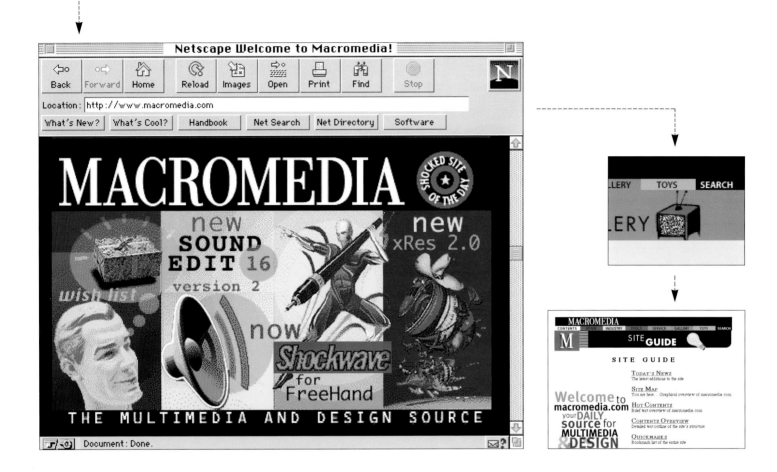

Netscape Welcome to Macromedia!

Back | Forward | Home | Reload | Images | Open | Print | Find | Stop

Location: http://www.macromedia.com

What's New? | What's Cool? | Handbook | Net Search | Net Directory | Software

MACROMEDIA

SHOCKED SITE OF THE DAY

new **SOUND EDIT 16** version 2

new xRes 2.0

wish list

now **Shockwave** for FreeHand

THE MULTIMEDIA AND DESIGN SOURCE

Document: Done.

LLERY | TOYS | **SEARCH**

MACROMEDIA

CONTENTS | BRAIN | INDUSTRY | TOOLS | SERVICE | GALLERY | TOYS | SEARCH

M SITE **GUIDE**

SITE GUIDE

TODAY'S NEWS
The latest additions to the site

Welcome to macromedia.com your **DAILY** **source** for **MULTIMEDIA** **&DESIGN**

SITE MAP
You are here... Graphical overview of macromedia.com

HOT CONTENTS
Brief text overview of macromedia.com

CONTENTS OVERVIEW
Detailed text outline of the site's structure

QUICKMARKS
Bookmark list of the entire site

MACROMEDIA

CONTENTS | BRAIN | INDUSTRY | TOOLS | SERVICE | GALLERY | TOYS | SEARCH

M INDUSTRY **PULSE**

Welcome to Industry Pulse

Here's the place to explore the bright present and brilliant future of multimedia and design. By the definition, the multimedia industry is really taking off. At present, there are 12 million multimedia personal computers installed and the total market size (for both hardware and software) is $10 billion USD. Market analysts report an average annual growth rate of 24 percent and expect the overall market to triple in the next four years.

In sub-sections, we detail and illustrate the research behind this projected growth and identify opportunities in the field. Who knows, perhaps defining multimedia will become less important than what it represents to you: a wise investment, a way to enhance your communications, a new career.

M MACROMEDIA

INTERNATIONAL ACCESS

MACROMEDIA

CONTENTS | BRAIN | INDUSTRY | TOOLS | SERVICE | GALLERY | TOYS | SEARCH

M COOL **TOOLS**

Welcome to Cool Tools

Welcome to Macromedia's Cool Tools workshop. Macromedia offers the best family of multi-platform tools which enable you to succeed in multimedia, graphic design and online publishing. It's also a place to contribute your ideas through Macromedia's Product Wish Lists. If you've got the imagination, we have the tools to power your ideas.

Tools to Power Your Ideas

FreeHand | Fontographer | xRes | Extreme 3D

FreeHand Graphics

Shockwave

Director | FreeHand

Action! | Authorware | C
Director | Director Multimedia Studi
FreeHand | FreeHand Graphics Studio | Shock

Shockwave SHOCKWAVE GAL

□ BANNERS
□ LOGOS
□ GAMES
□ CUSTOM MULTIMEDI

Fish Bowl
(1.2 MB)

Shock Me
(55 K)

MULTIMEDIA DESIGNER

Graffito/Active8 leads the field of design firms experimenting with Director animations on their home pages. One of the most important online developments is the release of Macromedia's Shockwave plug-in for Netscape. This software makes it possible for Web designers to place interactive Macromedia Director files or animations into their Web pages, which can be viewed by anyone running Netscape.

Two navigation options are offered for getting to the contents page. Clicking on the "shocked" button takes the viewer to an animated introduction that includes high-quality sound and moving text leading to the contents page. Clicking on the "standard" button offers a direct link to the contents page. The latter option uses less bandwidth and gets the viewer to the contents page more quickly, but the former option is more entertaining.

Incorporating this animated opening into Graffito/Active8's Website gives the company a chance to show visitors and potential clients a more complete picture of their multimedia design capabilities.

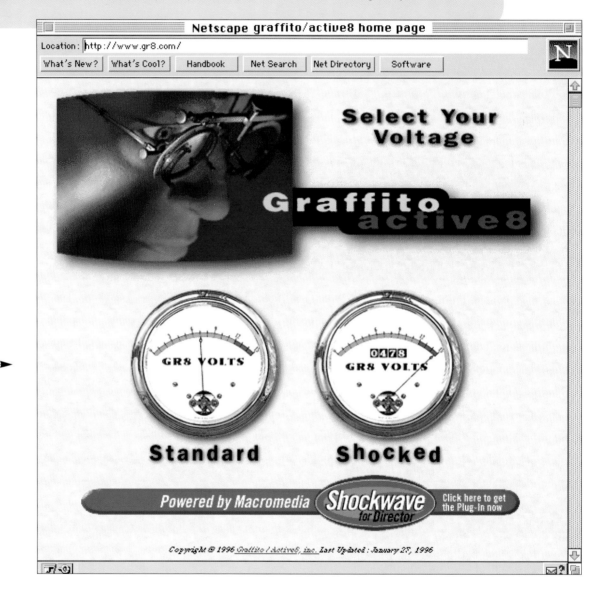

Project: **Graffito/Active8 Website**
Design Firm: **Graffito/Active8**
Designers: **Tim Thompson, Jon Majerik**
Illustrator: **Josh Field**
Programmer: **Jon Majerik**
Photographers: **Ed Whitman, Taran Z, Michael Northrup**
Authoring Program: **HTML**
Platform: **Browser Related**
URL: **http://www.gr8.com**

DIGITAL PORTFOLIO

Clement Mok designs' Web Site has garnered the attention of the design community and has won numerous awards for its creative use of color and imagery, just like many of the design firm's print projects. Illustrated icons—used for buttons—link to subsequent pages, and color-coded buttons and banners help navigate to each area. The color palette used for the site has been carefully minimized to give viewers the quickest download possible.

Subsequent pages offer clients and visitors information about the company, case studies, and a portfolio showing some of their work. Several unique items are incorporated into the site including an animated push (television slide show) for one of Clement Mok's clients on the home page, and a Net Cafe page that requires 3-D glasses to view properly.

Project: **Clement Mok designs' Web Site**
Design Firm: **Clement Mok designs**
Producer: **Sheryl Hampton**
Creative Director: **Clement Mok**
Associate Creative Director: **Claire Barry**
Illustrator: **Andrew Cawrse**
Programmers: **Mark Anquoe, Michael Clasen, Stephan Bugaj**
Authoring Program: **HTTP, CGI**
Platform: **Browser Related**
URL: **http://www.cmdesigns.com**

Home Financial Network's Website is an example of the potential for business functions conducted the traditional way translating to online use. A grayscale image, tiled in the background, frames the color image in the foreground, which keeps the viewer's eye focused on important areas.

Shades of green and collaged money convey the feeling of a financial institution, and the illustrated icons used for the three main buttons are well representative of the following links. On subsequent pages, the designers use color sparingly, choosing to focus the viewer's eye on icons that link to other areas of the site.

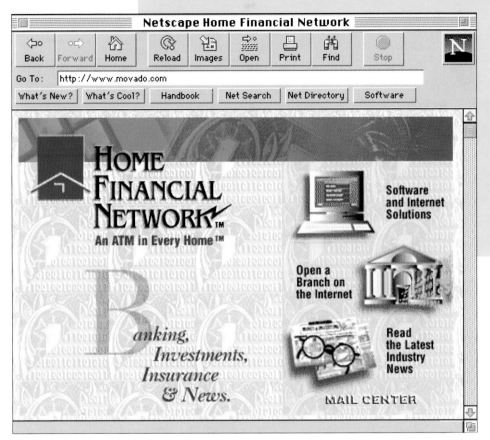

Project: **Home Financial Network Website**
Client: **Home Financial Network Inc.**
Design Firm: **The Design Office Inc.**
Designers: **Yung Beck, Dave Green, Andrea Flamini, Joe Feigenbaum**
Programmer: **Andrea Flamini**
Authoring Program: **HTML**
Platform: **Browser Related**
URL: **http://www.homenetwork.com**

ARTS ORGANIZATION

The American Institute of Graphic Arts Website, created by Graffito/Active8, lends credibility to the organization by showing well-designed pages without using too many of the clichéd bells and whistles of Web design.

A single image icon with branching text buttons is used to navigate the contents, and is positioned at the top right of each page to give continuity to the site, adding to the ease of navigatiion.

To the left of the contents icon are buttons that link to information relating to AIGA and the services the organization offers. These buttons float on a background that changes color with each area that the user visits, adding further continuity to the design.

Project: **AIGA Website**
Client: **American Institute of Graphic Arts**
Design Firm: **Graffito/Active8**
Designers: **Tim Thompson, Jon Majerik**
Programmer: **Jon Majerik**
Photographer: **Morton Jackson**
Authoring Program: **HTML**
Platform: **Browser Related**
URL: **http://www.aiga.org**

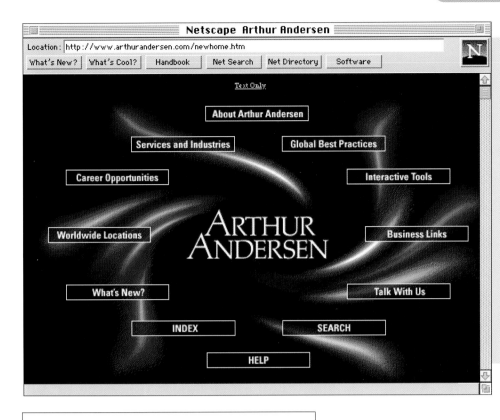

Arthur Andersen's business consulting Website easily could be dry and conservative, but Eagle River Interactive gives the pages an elegant, contemporary look by combining the conservative symmetry of tiered boxes (used as navigational buttons) with unique and compelling icons.

Each icon represents a link to in-depth information about the company's business consulting services. The swirls on the home page add color and movement, creating a focal point that draws the viewer's eye toward the center of the page and the client's name.

Project: **Arthur Andersen Business Consulting Website**
Client: **Arthur Andersen Business Consulting**
Design Firm: **Eagle River Interactive**
Designers: **Staff**
Authoring Program: **HTML**
Platform: **Browser Related**
URL: **http://www.arthurandersen.com/newhome.htm**

MULTIMEDIA DESIGNER

imedia's Website uses the strong visual recognition of its home, San Francisco, as a graphic theme. Three consecutive images of the Golden Gate Bridge, in various states of rendering, open the Website, while banners on following pages continue the bridge motif. This establishes imedia as a strong regional design firm, with potential for global outreach.

For quicker downloads, imedia uses generous amounts of white space and smaller images to draw the viewer's eye to specific areas of the portfolio. The whimsical use of colorful shirt buttons for navigational buttons adds a touch of humor to their portfolio presentation.

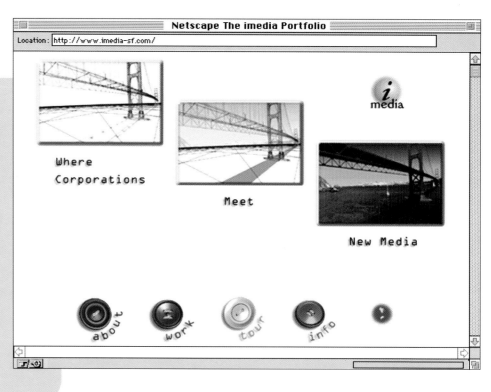

Project: **imedia Website**
Design Firm: **imedia Interactive Multimedia**
Designers: **B. Almashie, H. Campos**
Illustrators: **B. Almashie, H. Campos**
Programmers: **B. Almashie, H. Campos**
Authoring Program: **HTML**
Platform: **Browser Related**
URL: **http://www.imedia-sf.com**

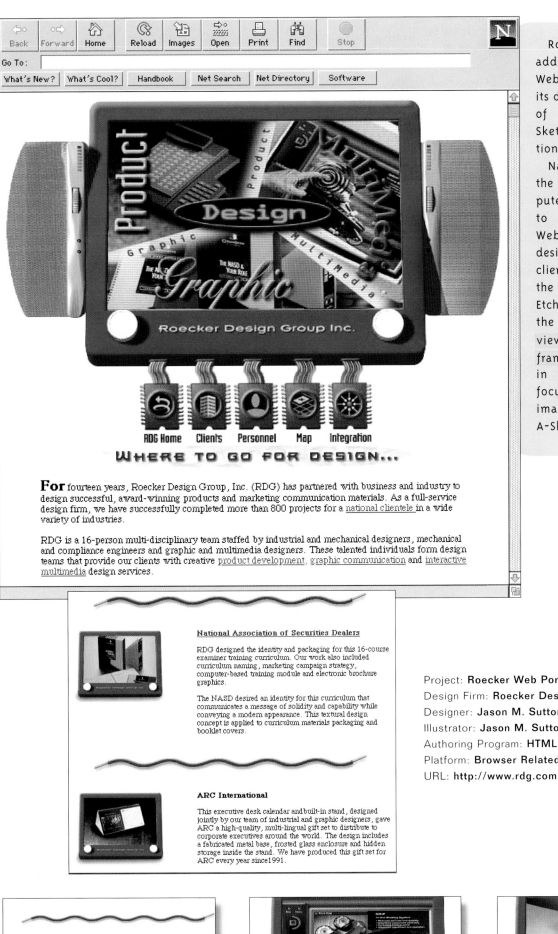

Back Forward Home Reload Images Open Print Find Stop

Go To:

What's New? What's Cool? Handbook Net Search Net Directory Software

Product Design Graphic MultiMedia Graphic

Roecker Design Group Inc.

RDG Home Clients Personnel Map Integration

WHERE TO GO FOR DESIGN...

For fourteen years, Roecker Design Group, Inc. (RDG) has partnered with business and industry to design successful, award-winning products and marketing communication materials. As a full-service design firm, we have successfully completed more than 800 projects for a national clientele in a wide variety of industries.

RDG is a 16-person multi-disciplinary team staffed by industrial and mechanical designers, mechanical and compliance engineers and graphic and multimedia designers. These talented individuals form design teams that provide our clients with creative product development, graphic communication and interactive multimedia design services.

Roecker Design Group adds a touch of humor to its Web portfolio by centering its design around the image of a high-tech Etch-A-Sketch replacing a traditional monitor.

Navigational buttons in the form of stylized computer chips link the viewer to various areas of the Website, unifying the design theme. While in the client area of the Website, the viewer can click on the Etch-A-Sketch to the left of the descriptive copy and view a magnified image; framing the portfolio pieces in this manner helps to focus the viewer on the images inside the Etch-A-Sketch.

National Association of Securities Dealers

RDG designed the identity and packaging for this 16-course examiner training curriculum. Our work also included curriculum naming, marketing campaign strategy, computer-based training module and electronic brochure graphics.

The NASD desired an identity for this curriculum that communicates a message of solidity and capability while conveying a modern appearance. This textural design concept is applied to curriculum materials packaging and booklet covers.

ARC International

This executive desk calendar and built-in stand, designed jointly by our team of industrial and graphic designers, gave ARC a high-quality, multi-lingual gift set to distribute to corporate executives around the world. The design includes a fabricated metal base, frosted glass enclosure and hidden storage inside the stand. We have produced this gift set for ARC every year since 1991.

Project: **Roecker Web Portfolio**
Design Firm: **Roecker Design Group, Inc.**
Designer: **Jason M. Sutton**
Illustrator: **Jason M. Sutton**
Authoring Program: **HTML**
Platform: **Browser Related**
URL: **http://www.rdg.com**

RDG Product Development Portfolio

This computer-based, interactive multimedia presentation product development group's portfolio takes full advantage RDG's integrated media strategy and serves as an impact marketing and sales presentation tool. With one show, not only demonstrate our product design capabilities but showcase our graphic and multimedia design capabilities.

This particular application of interactive multimedia desig chosen to allow the presenter many options of navigating through the information and therefore having the ability literally customize each presentation to the client's needs "micro view" feature allows us to discuss each product's

PROMOTIONAL PRESENTATION

The Kellogg Website is aimed at a younger audience, but adults will also enjoy exploring and browsing through the "Kellogg's Clubhouse." The interface comprises bright, storybook-like illustrations that lead from one area to the next. The Clubhouse theme allows visitors to navigate through rooms consisting of clickable objects (such as the Foyer, which has a clickable phone, photos and doorways) that lead to other pages.

The designers at Magnet Interactive created online activities to engage the viewer for extended periods. One such area is the Valentine's Day page, where digital valentines are composed and sent to others on the Internet. The lounge area links to the other online activity, a coloring book that allows the viewer to choose specific colors and click on hotspots to color the images.

The Kellogg site is a good example of how a design concept can promote a brand, while masking specific products. This site sells Kellogg, not Kellogg's Corn Flakes or Froot Loops.

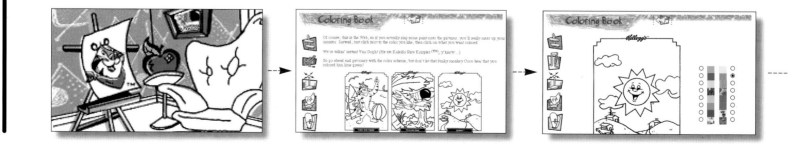

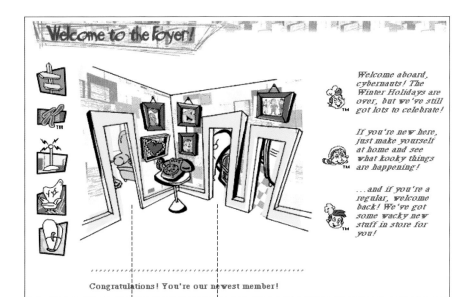

Welcome to the Foyer!

Welcome aboard, cybernauts! The Winter Holidays are over, but we've still got lots to celebrate!

If you're new here, just make yourself at home and see what kooky things are happening!

...and if you're a regular, welcome back! We've got some wacky new stuff in store for you!

Congratulations! You're our newest member!

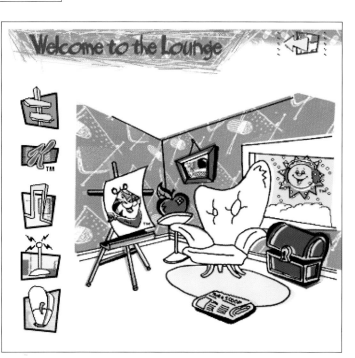

Welcome to the Lounge

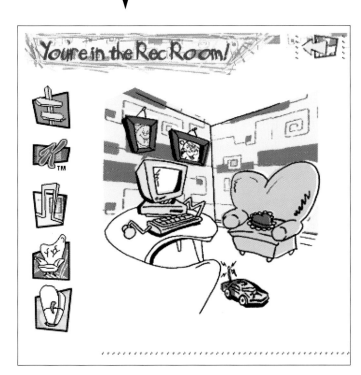

You're in the Rec Room!

Project: **Kellogg Website**
Client: **Kellogg Company**
Design Firm: **Magnet Interactive Communications, LLC**
Producer: **Lucy Lieberman**
Designers: **William C. Colgrove, John McGarity, Shannon Roach, Laura Mitchell**
Illustrator: **William C. Colgrove**
Programmer: **Dave Mitchell, John Mitchell, Claudia Anfuso**
Authoring Program: **HTML**
Platform: **Browser Related**
URL: **http://www.kelloggs.com**

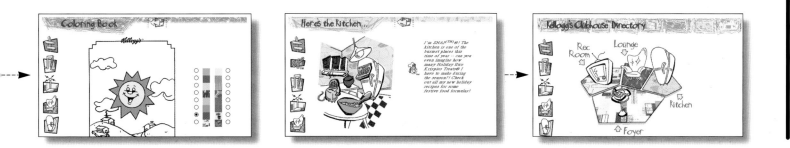

PROMOTIONAL PRESENTATION

Ketchum Kitchen's Website showcases a division of Ketchum Communications that specializes in public relations and advertising efforts for food-related clients. This home page from Red Dot Interactive is a food lover's paradise: a working test kitchen that offers a library of easy-to-make recipes, and a treasure trove of useful cooking tips.

Visitors to the site are greeted by bright graphics that offer easy access to the three main areas of the site. Red Dot has created a site that not only promotes Ketchum, but also provides real value for Web users.

Netscape KETCHUM KITCHEN

Back | Forward | Home | Reload | Images | Open | Print | Find | Stop

Location: http://www.recipe.com/

What's New? | What's Cool? | Handbook | Net Search | Net Directory | Software

KETCHUM KITCHEN

dear sandy · fresh this week · what's cooking

Mmm...something delicious is cooking in the Ketchum Kitchen. Come on in! Pour yourself a cup of coffee.

Welcome to a working test kitchen in San Francisco, the kitchen of Ketchum Public Relations Worldwide, where food is our passion -- and our business.

We develop recipes, test ingredients, track food trends and dream up creative new ways to use all kinds of food and beverage products.

DEAR SANDY

Dear Food Lovers,

Chinese New Year is coming up soon. Why not make a special New Year's Feast? We provide two recipes in the Quick Cook section of What's Cooking.

Our Valentine's Day feature in the Market Basket section of Fresh this Week offers heart-healthy tips for year-round cooking.

And don't forget to fill out a Feedback form if you haven't yet done so. We value input from you about your cooking habits to guide us in recipe selection for our site. It's especially important to hear from you this week, because next week we'll be changing our questions to focus on bread machines.

If you've sent an e-mail to us and haven't heard back, please be patient, because we are swamped with requests right now, but we do answer every e-mail question Also, please be sure your e-mail address is correct when you send your question. We've had a number of our responses returned because of faulty addresses.

Happy Chinese New Year!

WHAT'S COOKING

What to cook? What to eat? An age-old problem. Check out these solutions.

Ketchum Cookbook

We're building a cookbook! Here you'll find deliciously easy appetizers; bread machine bread that tastes as good as grandma's; main dishes made in minutes; good things to grill; tantalizing, deceptively lowfat desserts... More tempting recipes will be added continually to this database.

Quick Cook

Fast and good. These recipes help meet the dinnertime crunch. Even if you left work late.

WHAT'S COOKING

KETCHUM COOKBOOK

Here's a library of our favorite recipes. Search by recipe category or by key ingredient. Keep your key ingredient general (to find steak, search beef; to find potatoes, search vegetables). Or browse through the whole collection.

Search by Category.................... Appetizers / Breads / Cakes / Condiments

Find

Project: **Ketchum Kitchen**
Client: **Ketchum Communications**
Design Firm: **Red Dot Interactive**
Creative Director: **Judith Banning**
Authoring Program: **HTML**
Platform: **Browser Related**
URL: **http://www.recipe.com**

WHAT'S COOKING

What to cook? What to eat? An age-old problem. Check out these solutions.

Ketchum Cookbook

We're building a cookbook! Here you'll find deliciously easy appetizers; bread machine bread that tastes as good as grandma's; main dishes made in minutes; good things to grill; tantalizing, deceptively lowfat desserts... More tempting recipes will be added continually to this database.

Quick Cook

What's fresh, what's hot, what's happening? Here's the place to find out.

Celebrity Chef

Who's making food news? Who's influencing what we buy and how we eat? Meet our guest.

Market Basket

FRESH THIS WEEK

CELEBRITY CHEF

Gary Danko started cooking when he was six. And he hasn't stopped since. Today, he is chef of The Dining Room at the elegant Ritz-Carlton, San Francisco, preparing fabulous dishes that have won him many accolades, including the James Beard Best American Chef: California, award last spring. As a child, Gary's first culinary adventures began with Betty Crocker cookbooks. Today, this French-trained chef wins critical acclaim from national wine and food critics. Gary shares a recipe for Grilled Beef with Dried Tomatoes and Artichoke Hearts, which he has adapted for home

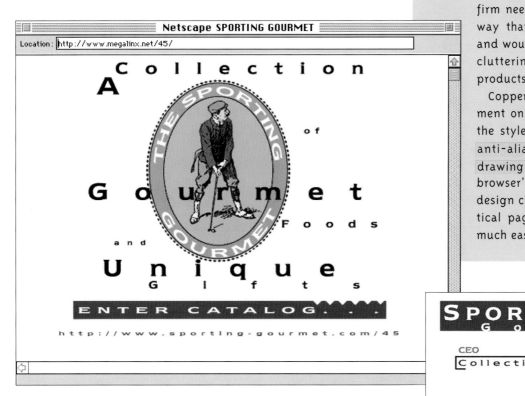

Sporting Gourmet's online catalog posed a challenge to CopperLeaf Design Studio: the design firm needed to present the catalog in a way that would be simple to navigate and would display the products, without cluttering the pages or burying the products under too many links.

CopperLeaf used a contemporary treatment on the home page, and continued the style throughout the catalog, using anti-aliased text and bullets from a drawing program, rather than rely on the browser's bitmapped type. To keep the design clean the studio used longer vertical pages that load slowly, but allow much easier navigation.

Project: **Sporting Gourmet Catalog**
Client: **Steve Craver**
Design Firm: **CopperLeaf Design Studio**
Designers: **Steve Shaw, Jason Brua**
Illustrator: **Cathleen Carbery-Shaw**
Programmer: **Steve Shaw**
Photographer: **Lisa Marie Deville**
Authoring Program: **HTML**
Platform: **Browser Related**
URL: http://**www.sporting gourmet.com/45**

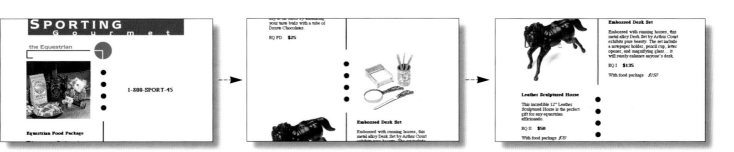

WEB MAGAZINE

Macworld Online offers articles from the latest issues of its printed counterpart, as well as special feature articles, reviews and news that are exclusive to the online version.

The Website is primarily text-based, with hyperlinks for navigating through the different areas. Icons and graphics are used only on the opening screen, and as banners on linked pages, eliminating long downloads.

Keeping the magazine in text format lets designers and editors easily update the magazine, which is important, considering the tight deadline of creating a monthly news magazine.

Netscape Macworld Online

Back Forward Home Reload Images Open Print Find Stop

Location : http://www.macworld.com/

What's New? What's Cool? Handbook Net Search Net Directory Software

Macworld ONLINE

We also offer a text-only home page for faster loading.

is still kicking, read all about it... march 1996

Macworld Best Mac Products

SEARCH contents

MESSAGE BOARDS SOFTWARE LIBRARY NET SMART TECHNOCULTURAL CAFE CONTACT MACWORLD

Macworld Software Library

Net Smart

Technocultural Café

Macworld Features

Macworld News

Project: *Macworld Online*
Design Firm: **Macworld Online**
Designers: **Staff**
Programmer: **Paul Devine**
Authoring Program: **HTML**
Platform: **Browser Related**
URL: **http://www.macworld.com**

Radio Macworld

Welcome to Radio Macworld, a regular audio

If you're a member you can enter the Macworld member register now.

Presto Studios' home page designers chose to keep the interface clean and uncluttered by eschewing traditional buttons, instead using colorful, rendered 3-D titles to link to associated pages. The linked pages continue the title style as headings at the top of each page, with a subtle change to each that includes a smoke effect billowing around them.

Tiled background images of Presto Studios' logo and name reinforce a design that keeps the company's identity visible at all times, and preliminary line drawings from *Buried in Time* (the company's most successful game) are tiled as a background on the "Available Titles" page.

Though the Website is primarily self-promotional, Presto Studios knows that, in order to attract return visitors, it must offer added attractions. The "Destinations" page fulfills this by providing viewers links to gaming magazines and related Websites.

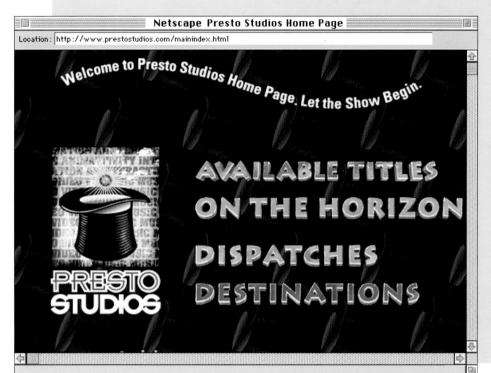

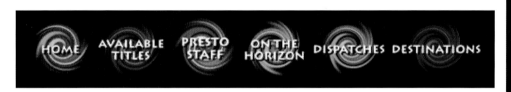

Project: **Presto Studios Website**
Design Firm: **Presto Studios**
Designers: **Frank Vitale, Eric Fernandes**
Programmers: **Eric Fernandes, Prakash Kirdalani**
Authoring Program: **HTML**
Platform: **Browser Related**
URL: **http://www.prestostudios.com**

DIGITAL PORTFOLIO

Primo Angeli's Web portfolio shows the simplicity and impact of a well-packaged design. Well-known for its traditional print design, the firm quickly is becoming a leader in multimedia design as well.

As a brand and packaging design firm, the company knows how to get a message across in small spaces, and the Web is a perfect crossover medium for this aspect of the business.

Large images and typography convey their messages clearly, and put emphasis on content rather than the navigation.

CAUTION:
Web Site may be subject to violent and abrupt change!

Project: **Primo Angeli Inc. Website**
Design Firm: **Primo Angeli Inc.**
Creative Director: **Primo Angeli**
Art Directors: **Primo Angeli, Brody Hartman**
Designers: **Philippe Becker, Dom Moreci**
Illustrator: **Mark Jones**
Programmer: **Dom Moreci**
Authoring Program: **HTML**
Platform: **Browser Related**
URL: **http://www.primo.com**

On the ocean that comprises the Internet, powerful signals and memorable messages are the best lures for fishing.

Netscape Shannon Roach

Location: http://www.idsonline.com/userweb/shannonr/

INNOVATE

INTERACTIVE DESIGN
shannon roach

EXPERIENCE
BACKGROUND

shannonr@ids2.idsonline.com
202.965.2027

Copyright 1995 Shannon Roach

MULTIMEDIA DESIGNER

Shannon Roach's Web design is both innovative and contemporary, as the home page to this site clearly shows.

The hard edges of the black-and-white space that divides the page complement the drop shadows, layered headlines and modern type treatments.

The blurred swatch of gold blended into the heading adds depth and movement to the interface.

Only two buttons reside on the home page, both clearly labeled for easy navigation. Shannon's flair for creating high-quality, contemporary design is not limited to her personal work; the portfolio area of her Website demonstrates her ability to adapt this style to many different commercial and professional projects.

Project: **Personal Website**
Design Firm: **Shannon Roach**
Designer: **Shannon Roach**
Authoring Program: **HTML**
Platform: **Browser Related**
URL: **http://www.idsonline.com/userweb/shannonr**

MAKING MULTIMEDIA: FROM VAPORWARE TO GOLDRUSH

INTRODUCTION
CGI
PRODUCTION
ART DIRECTION
INTERACTIVE STORYTELLING
PROGRAMMING
COMPRESSION
EXAMPLES

Introduction | CGI | Production | Art Direction
Interactive Storytelling | Programming | Compression | Examples

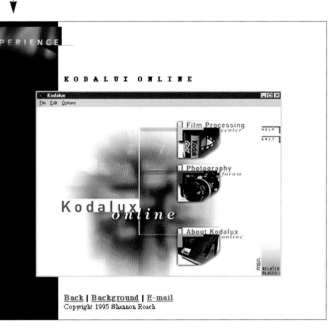

EXPERIENCE

KODALUX ONLINE

Kodalux online

Film Processing
Photography forum
About Kodalux online

Back | Background | E-mail
Copyright 1995 Shannon Roach

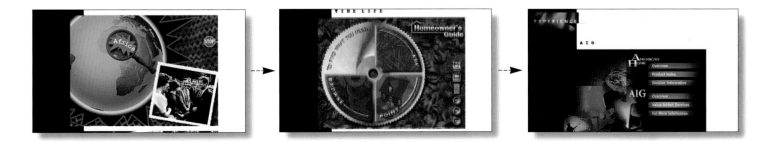

DIGITAL PORTFOLIO

Vizbyte's home page shows what is possible when a minimalist approach is taken with interface design. Rewarding for adventurous people who enjoy exploring interfaces, the home page image offers a minimum of description, with no clearly defined buttons for navigation.

Visitors who want information immediately upon entering need only scroll to the bottom of the page for hypertext links. The introductory graphic is divided into four distinct quadrants, delineated by muted colors. Clicking on one of these quadrants leads to other areas of the Website, such as a company portfolio and bios of the designers.

Project: **Vizbyte Website**
Client: **bYte a tree productions/Stellarvisions**
Design Firm: **bYte a tree productions**
Designers: **Stella Gassaway, Don Haring**
Illustrator: **Don Haring**
Programmers: **Gerry Mathews, Margaret Anderson**
Photographer: **Gerry Mathews**
Authoring Program: **HTML**
Platform: **Browser Related**
URL: **http://www.vizbyte.com**

IN YOUR FACE

Women's Wire is the first interactive publication to recognize and address a female audience. Designed for women, by women, this online magazine is unique in its content; though the Web is predominantly male-oriented, recent statistics show that women are beginning to access the Web in larger numbers. The site is also unique in its design, with two versions of its home page interface: a traditional, static Web design and a "Shocked" home page that uses animated fades to introduce images, and section head numerals that change colors. Both designs offer viewers a clean interface for navigation, and show how the designers understand the parallels and differences between designing for print and designing for this new media of interactive publishing.

Project: *Women's Wire*
Design Firm: **Lisa Marie Nielsen Design**
Designer: **Lisa Marie Nielsen**
Authoring Program: **HTML**
Platform: **Browser Related**
URL: **http://www.women.com**

PROMOTIONAL PRESENTATION

The Delta Air Lines Website, designed by Modem Media, demonstrates innovative and effective multimedia branding. Visitors to the Website are greeted with a "client/server push" (a slide show of images) that cycles through each of the main navigational icons floating in the water below, displaying the various links within the site. This opening slide show is only a small part of a complex home page programmed with many hotspots throughout an imaginary skyline.

Clicking on any of the famous sights of the world takes the viewer to an informational page about the specific structure. Entering this site at night changes the homepage to an evening skyline.

Another example of the company's design and programming abilities can be seen in the "Plane Fun" area of the site. Here, the viewer can play a lottery-like scratch-off game for prizes (opposite page), or download an interactive floppy-disk-sized concentration game.

All of the pages in this site have been optimized for quick downloading, making them well-suited for their target audience: the time-conscious business traveler.

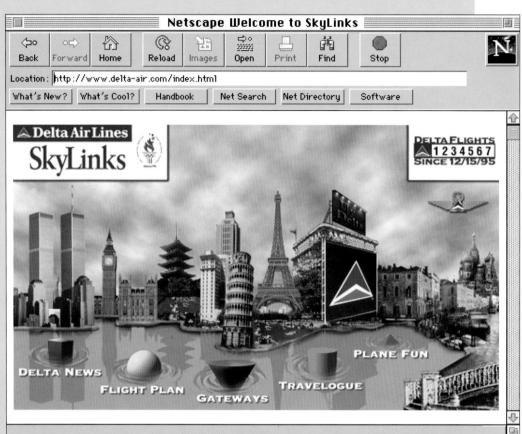

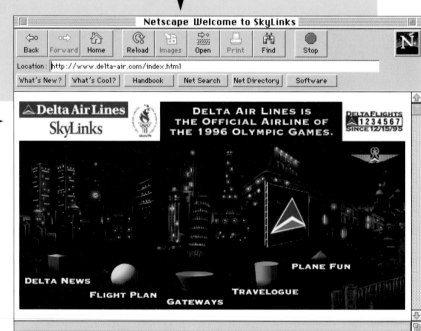

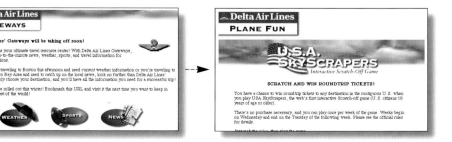

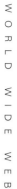


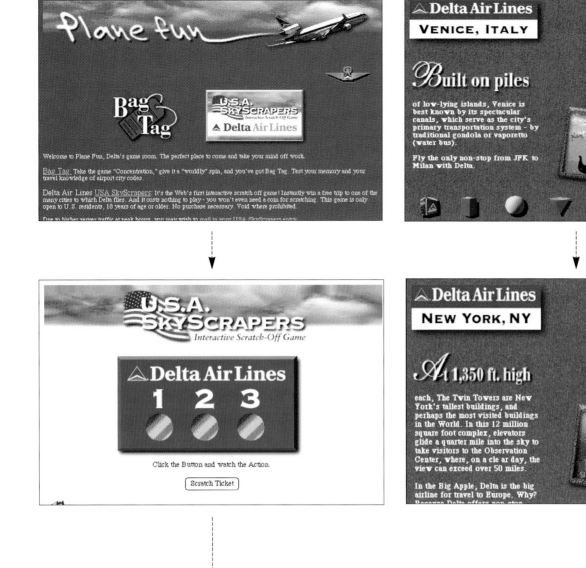

Project: **Delta Air Lines Website**
Client: **Delta Air Lines**
Design Firm: **Modem Media**
Creative Director: **Jamison Davis**
Senior Art Director: **David J. Link**
Art Director: **Melanie Ferguson**
Designer: **Riva Fischel**
Authoring Program: **HTML, CGI**
Platform: **Browser Related**
URL: **http://www.Delta-air.com**

DIGITAL PORTFOLIO

Canary Studios Website's main objective was to stay away from what the designers term the "beveled edge phenomenon," referring to the look of buttons with sides shaded to appear three-dimensional. This was accomplished by creating a graphically pleasing and colorful home page illustration that perfectly represents the company.

The large canary head offers visitors and potential clients a visual punch, while the colorful buttons below the bird's head offer clear and easy access to the rest of the site.

A colorful button bar keeps the continuity of the home page design; it offers jumps to other sections with a single mouse click, never going more than one level deep into the interface..

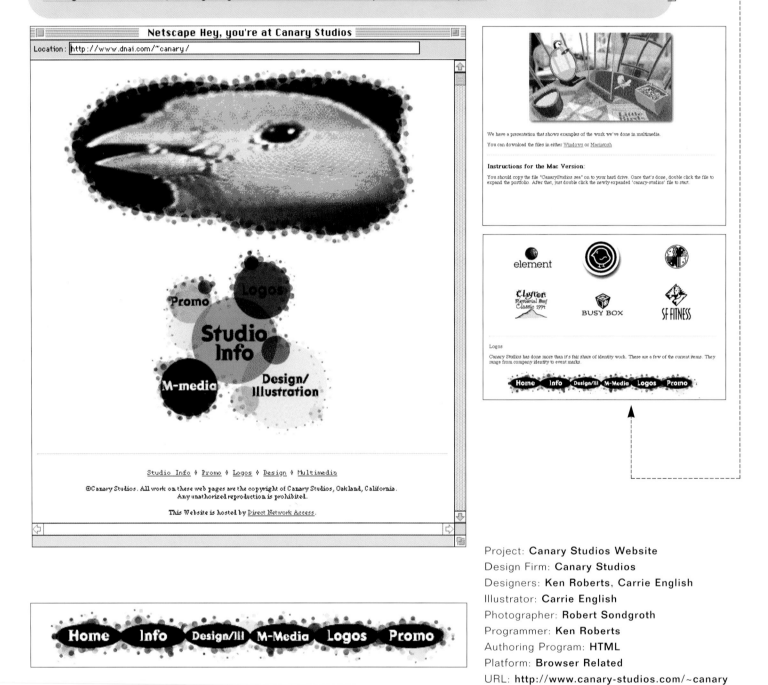

Project: **Canary Studios Website**
Design Firm: **Canary Studios**
Designers: **Ken Roberts, Carrie English**
Illustrator: **Carrie English**
Photographer: **Robert Sondgroth**
Programmer: **Ken Roberts**
Authoring Program: **HTML**
Platform: **Browser Related**
URL: **http://www.canary-studios.com/~canary**

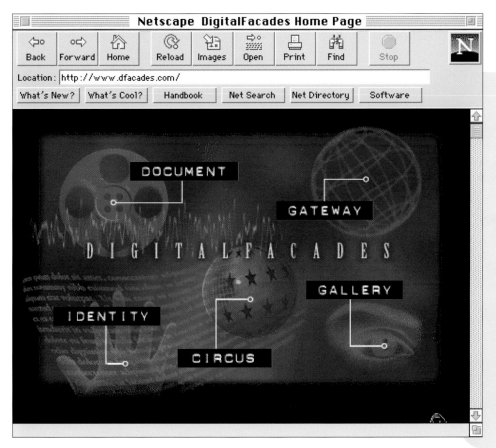

DigitalFacades' Web portfolio is built around a beautiful illustration that invites the viewer to explore the various areas of the company's site. Conceptual icons are woven into the illustration, which has been image-mapped to link to each area.

Subsequent links continue the look and feel of the home page image with top banner art, and each page offers a humorous or interesting quote for the viewer to read.

The DigitalFacades Website not only offers detailed information for the viewer to navigate through, but also makes it easy to return to the home page at any level of the Website by placing a "return to home page" button at the top of each page.

Project: **DigitalFacades Website**
Design Firm: **DigitalFacades**
Designer: **Oliver Chan**
Programmer: **Jane Lin**
Authoring Program: **HTML**
Platform: **Browser Related**
URL: **http://www.dfacades.com**

PROMOTIONAL PRESENTATION

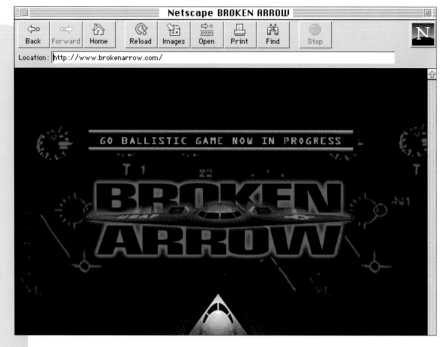

The *Broken Arrow* Website's main aim is to promote the motion picture of the same name. CBO's intention was to create a Website that would encourage extended stays and entice the viewer to return and explore again.

Using computer-readout greens, reds and blues against the black background conveys a feeling of urgency and drama in keeping with the movie's theme of nuclear terrorism. CBO created the Website so that viewers would have access to "top-secret" information (opposite page); giving them verbiage and excerpts from the movie, and a chance to sit in the cockpit of a stealth bomber.

The home page of *Broken Arrow* is unique in that it is a single, long, graphic page that viewers scroll through vertically, almost as if they were watching a movie trailer. This works well for the site, because the designers used a basic palette that allows for quick download and minimal refresh of the screen as the viewer scrolls through the page.

Project: *Broken Arrow* Website
Client: **20th Century Fox**
Design Firm: **CBO Multimedia, A Division of Cimarron, Bacon, O'Brien**
Creative Director: **Jill Taffet**
Executive Producers: **Scott Zimbler, Steve Siskind**
Designer: **Jill Taffet**
Additional Credits: **(see Developer's Listing)**
Authoring Program: **HTML**
Platform: **Browser Related**
URL: **http://www.brokenarrow.com**

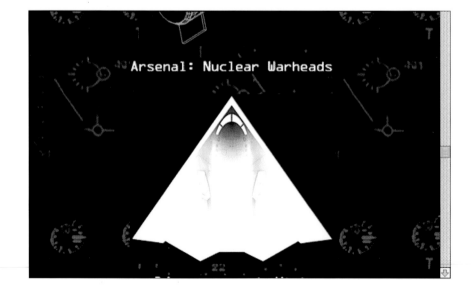

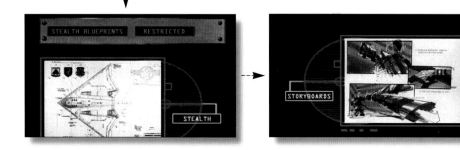

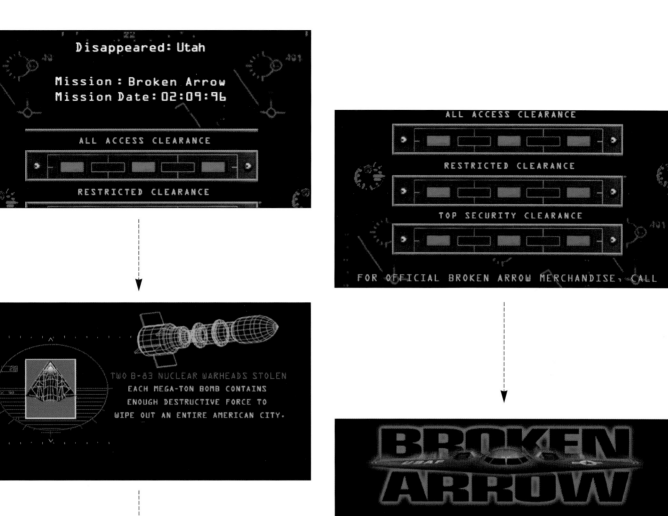

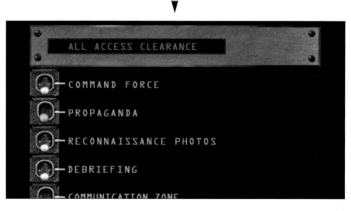

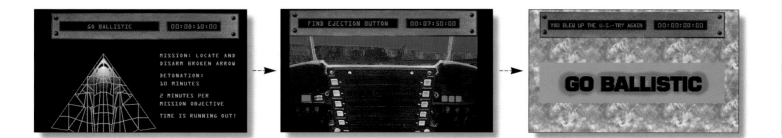

PROMOTIONAL PRESENTATION

Galaxy Latin America's Website begins to realize the potential of the World Wide Web to create a global village. The home page allows the viewer to choose between English, Spanish or Portuguese editions.

Magnet Interactive created interfaces that are effective in any language. Subtle yet refined illustrations depict the technology behind the company's product, using imagery and colors that evoke a feeling of satellite beams radiating through space.

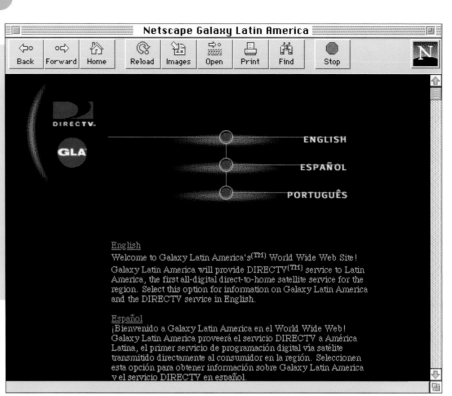

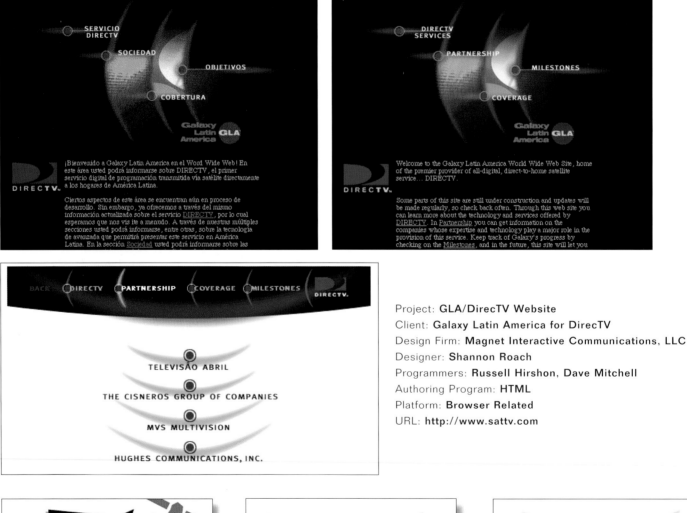

Project: **GLA/DirecTV Website**
Client: **Galaxy Latin America for DirecTV**
Design Firm: **Magnet Interactive Communications, LLC**
Designer: **Shannon Roach**
Programmers: **Russell Hirshon, Dave Mitchell**
Authoring Program: **HTML**
Platform: **Browser Related**
URL: **http://www.sattv.com**

The Epson Website breaks the Web rule-of-thumb that designers should avoid using large amounts of text in their design. Instead of using graphical or icon-based buttons as the focal point, Digital Facades uses colorful typographical elements as the navigational buttons for this site. Collage images were added, producing a clean, contemporary look that invites the user to explore the different aspects of the site. Visitors to the site looking for a specific topic will find all areas clearly labeled and easily accessible.

The home page sets the tone of the project, with its large type brackets as borders for the center image. This design element is repeated on each of the main pages, along with colorful type treatments, collage, and dotted lines and arrows that give the Epson Website an artistic flavor.

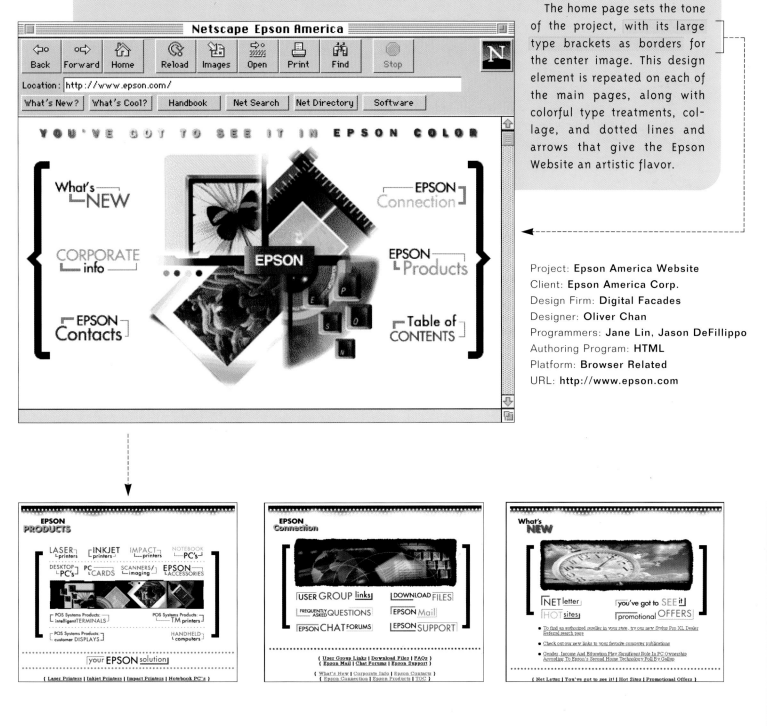

Project: **Epson America Website**
Client: **Epson America Corp.**
Design Firm: **Digital Facades**
Designer: **Oliver Chan**
Programmers: **Jane Lin, Jason DeFillippo**
Authoring Program: **HTML**
Platform: **Browser Related**
URL: **http://www.epson.com**

Kiosks

Kiosks are free-standing terminals used by large numbers of people to access or input information. They were originally designed to replace a bank teller, salesperson or instructor. Now, they are commonly used to provide information, such as catalog sales or customer support. Though many of these commercial uses of kiosks are now moving to the Internet (with its largely affluent audience of consumers familiar with technology), kiosks reach out in a perhaps more egalitarian manner to audiences of all ages and experience in locations as varied as trade shows to museums.

•

As with any design project, the kiosk designer must first consider the background, age and interest of the potential audience. If the kiosk is in a public place, it is very possible that users may not have had any experience with the interface conventions of traditional computer programs and operating systems, and the interface must address this issue. The program interface determines the user's understanding and subsequent navigation through the interactive program. A good interface makes even the most complex interactivity transparent to the user: a great interface also makes it fun.

•

Designing an interface for a public access kiosk is always about creating a very elegantly simple diagram of the available information—an interactive map, if you will. If possible, all of the sections should be on an introduction screen so users don t need to delve too deeply for content. If there is a way to keep users moving laterally through the content, the momentum keeps them engaged and prevents them from resetting the experience by hitting the "main menu" button.

•

Devices often used include onscreen mini-indexes of all the main menu items in a pop-up menu, or buttons that branch to a section that has not been viewed yet. It is helpful if these methods address varying interests and experience levels by allowing the user to customize the program and to create associations between subjects that

may be related even if the design does not place these subjects in the same category. Narrow paths through a linear presentation result in restricted classification system that does not allow subtle associations.

•

Throughout the program, a consistent interface metaphor keeps the user in control of the program. Switching interfaces can disorient users and create confusion, though this is a general design principle that can be broken when a new graphic metaphor enhances communication. Constant feedback to the user—highlighting, sounds at the touch of an on-screen button, or prompts asking direction or approval—are also routes to an engaging program. A little unexpected wit and humor in feedback can significantly increase the fun factor.

•

Audio is important as an indicator of proximity, importance, or mood in general. The context and environment of the kiosk can significantly influence sound design. The enclosure, acoustic properties of the space, and competing fixtures can enhance or impair the playback.

•

Thus, good interface design requires an interdisciplinary approach. The designer must consider the audience, the color scheme and composition of the design, the logic of the interactive map, the animation of screen elements and buttons, the power of music to create mood and attitude, and a bit of theatrical timing and excitement doesn't hurt, either. The free-standing informational kiosk brings the latest technologies to the widest possible audience. It will always present a challenge to designers to translate the technology into a human interface.

Robb Bush
Director of Product Development
Big Hand Productions

PROMOTIONAL PRESENTATION

Reebok 100 was developed as a traveling touch-screen exhibit for Reebok's 100th anniversary. The exhibit traveled to athletic events in ten different countries, including Japan and Chile. Designed to display and promote Reebok products to young adults, the kiosk has a distinctly raucous, MTV-like feel characterized by garish colors, hyperactive motion effects and contemporary fonts. To track demographics, users are asked to name their gender, and then select their age group, which offers a smart quip.

Users are encouraged to browse through the kiosk's content by the offer of a product coupon, which is issued by the kiosk when users touch three hidden items, found in various sub-sections. Not a challenging task, this requirement extends the length of time users spend viewing the content.

After volunteering demographic information, users are given options to explore nearly all of Reebok's current product line by touching one of sixteen areas of interest. After making this selection, users can view pieces of nearly 800MB of digitized animation and video.

Project: *Reebok 100*
Client: **Reebok International, Ltd.**
Design Firm: **Planet Interactive**
Designers: **Stoltze Design—Cliff Stoltze, Alyson Schultz**
Illustrator: **Mark Shaw**
Programmers: **Lisa Sirois, Rich Martin, Michel Milano**
Authoring Program: **Macromedia Director**
Platform: **Windows PC**

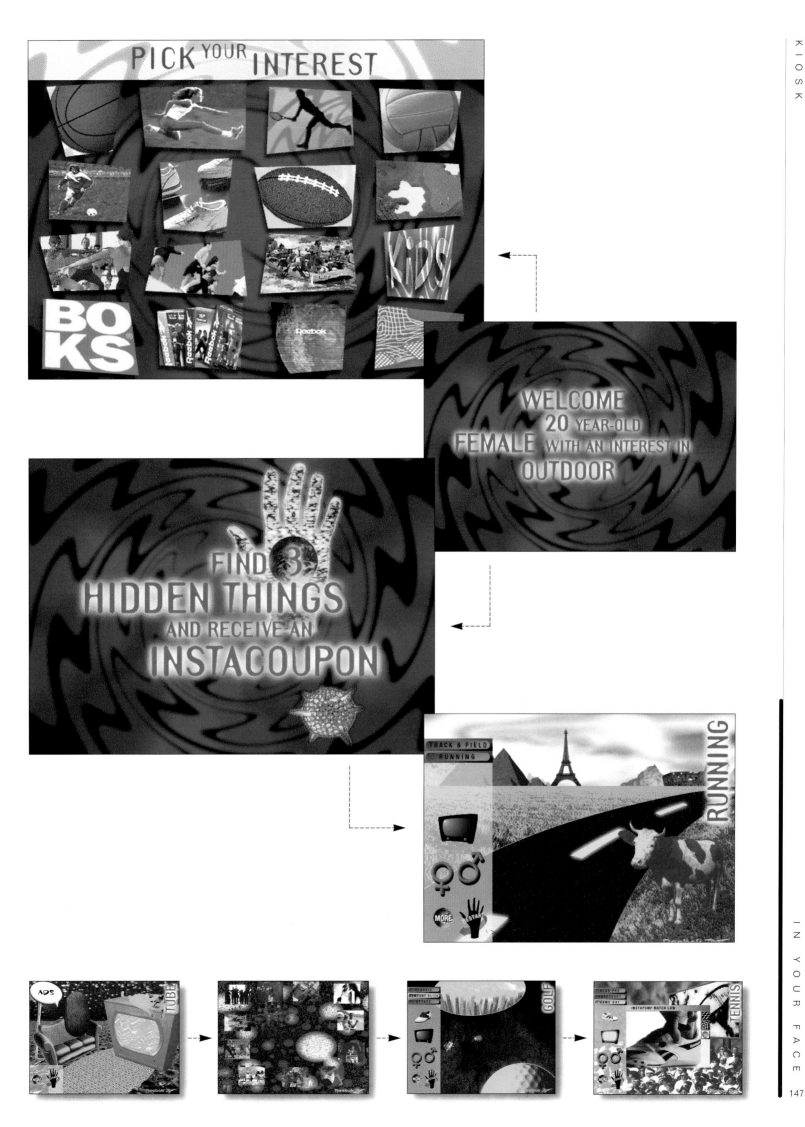

PROMOTIONAL PRESENTATION

Number Nine's *Are You Satisfied* kiosk, designed by Planet Interactive on CD-ROM, hawks PC and Mac graphics accelerator cards by illustrating for consumers what an accelerator card does and why they need one.

Number Nine's print advertising campaign includes lists of nine reasons to buy its products. To complement this campaign, Planet Interactive created multiple-choice question-and-answer screens. When questions are answered correctly, a creative animated sequence displays video, rotating and moving text treatments.

The kiosk uses a video loop to attract passers-by, continuing until user input starts the interactive part of the presentation. All pieces are complemented with original music and voiceovers.

Because they are displayed in superstore settings, these kiosks needed to be informative, interactive and engaging to set themselves apart from the plethora of existing self-running demos.

Project: *Are You Satisfied?*
Client: **Number Nine Inc.**
Design Firm: **Planet Interactive**
Designers: **Michael Milano**
Programmers: **Michael Milano, Rich Martin**
Photographer: **John Rae, John Rae Photography**
Authoring Program: **Macromedia Director**
Platform: **Windows**

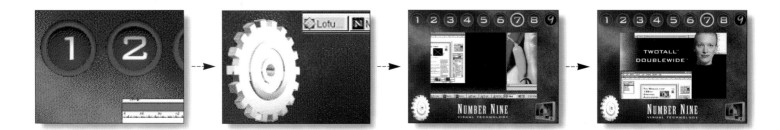

PROFESSIONAL TRAINING

Lares Corporation contracted with Media Magic to create a series of interactive training modules for in-house instruction. Corporations are finding it easier and more cost-effective to have their employees sit for a few hours a month at a computer, than to pay a hefty fee for corporate instructors; for the designer, training presentations have become a lucrative form of interactive multimedia design.

For the Lares project, the designers created distinctive 3-D interfaces for each module to replicate work employees are learning. The first module, shown on this page, conveys the look and feel of industrial metal, complementing the subject of Metal Removal Theory. A virtual clipboard was created as a sign-in sheet for the training, and keeps track of the areas which the employee has completed.

The second module covers an important aspect of the company's business: measuring techniques. This section repeats the look and feel of machined metal and three-dimensional space. Carefully rendered measuring tools not only resemble the physical tools, but also replicate their action, making them excellent learning aids.

Project: **Metal Removal Theory/Measuring Techniques Training**
Client: **Lares Research**
Design Firms: **Media Magic/Alien Bitdepth/ MC2 Design**
Designers: **Scott Holtsberry, Fran Holtsberry**
Illustrators: **Scott Holtsberry, Brian Curtis, Rocky Campbell**
Programmers: **Fran Holtsberry, Scott Holtsberry**
Authoring Program: **Authorware**
Platform: **Windows**

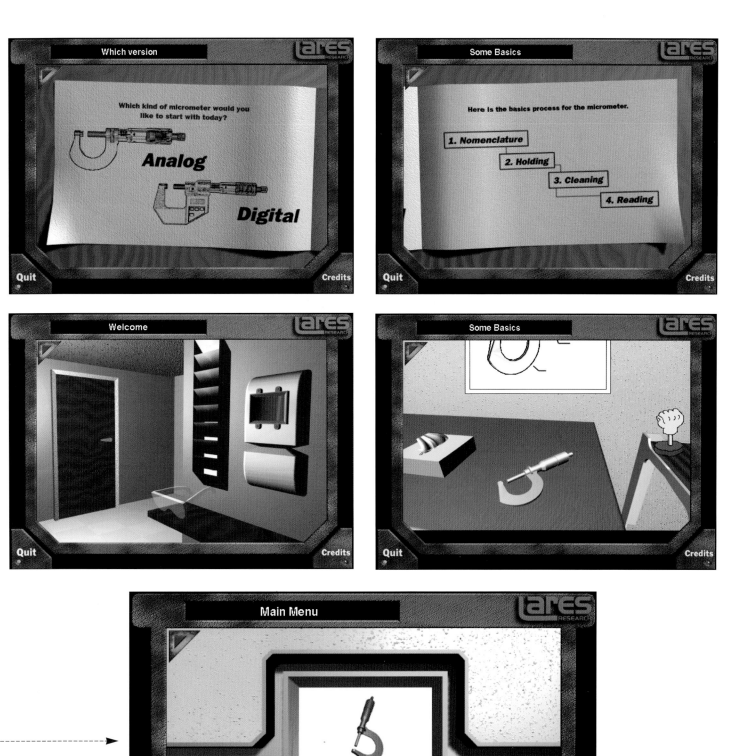

The Rock & Roll Hall of Fame commissioned four kiosks exhibits to be designed by The Burdick Group. All four exhibits are database-driven, allowing the user to search by topic (e.g., artist, album, DJ, or era), access relevant music, text or video, and then continue exploring with minimal on-screen instruction. The exhibit accommodates museum visitors who may have little or no computer experience.

The functional interface styling treats rock and roll as a respected art form. The designs are characterized by easily read type, artistic background images, and high-quality photography, audio, and video. Navigation is intuitive; users touch an album cover, thumbnail portrait of an artist, or song title to advance to another screen.

Achieving this high level of playback required a powerful array of hardware that includes two mirrored Sun Sparc servers taking up a total of 32 gigabytes of hard drive space.

Project: **Rock & Roll Hall of Fame and Museum**
Client: **Rock & Roll Hall of Fame and Museum**
Design Firm: **The Burdick Group**
Designers: **Bruce Burdick, Susan Burdick, Jerome Goh, Stuart McKee, Christian Anthony, Aaron Caplan**
Programmer: **Christian Anthony**
Authoring Program: **Macromedia Director**
Platform: **Macintosh, Sun Sparc Servers**

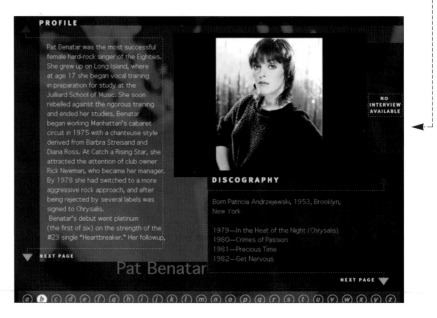

TOUCH SCREEN *to start program*

come see about me

Text from *The New ROLLING STONE Encyclopedia of Rock & Roll* Copyright © 1983, 1995 by Rolling Stone Press

SELECT ARTIST *from the menu*

come see about me

PROFILE

Pat Benatar was the most successful female hard-rock singer of the Eighties. She grew up on Long Island, where at age 17 she began vocal training in preparation for study at the Juilliard School of Music. She soon rebelled against the rigorous training and ended her studies. Benatar began working Manhattan's cabaret circuit in 1975 with a chanteuse style derived from Barbra Streisand and Diana Ross. At Catch a Rising Star, she attracted the attention of club owner Rick Newman, who became her manager. By 1978 she had switched to a more aggressive rock approach, and after being rejected by several labels was signed to Chrysalis.
Benatar's debut went platinum (the first of six) on the strength of the #23 single "Heartbreaker." Her followup,

NO INTERVIEW AVAILABLE

DISCOGRAPHY

Born Patricia Andrzejewski, 1953, Brooklyn, New York

1979—In the Heat of the Night (Chrysalis)
1980—Crimes of Passion
1981—Precious Time
1982—Get Nervous

NEXT PAGE

Pat Benatar

NEXT PAGE

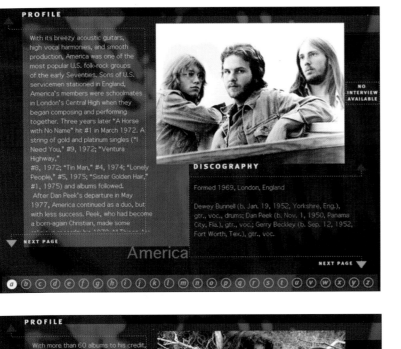

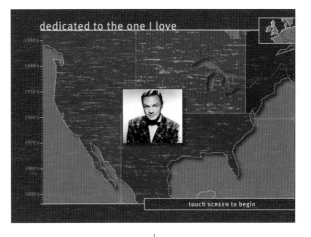

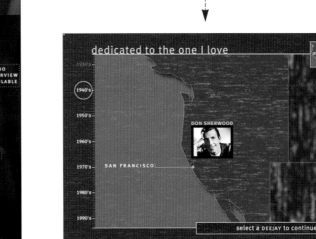

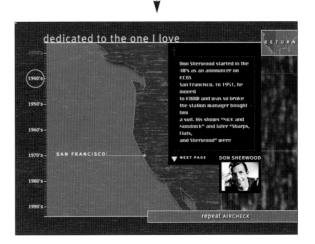

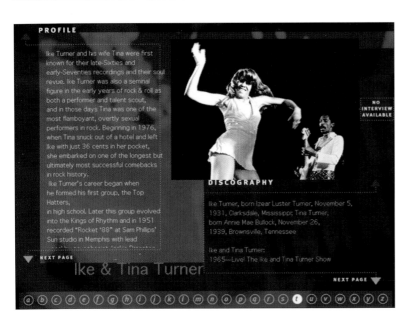

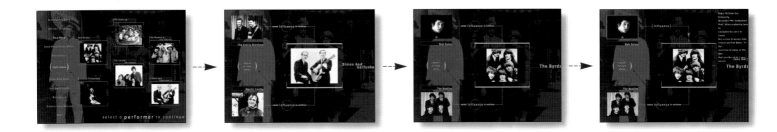

PROMOTIONAL PRESENTATION

PageNet's kiosk interface was designed to complement the wireless messaging company's product line. A realistically rendered 3-D model used for the interface creates a futuristic communication device users can identify and comfortably use. Realistic sound effects and illuminated buttons create for the kiosk visitor the effect of using an actual device, not a simulation.

Four button icons on the main contents screen link to additional information screens about PageNet products and services. The rounded metal edges of the device, lighting, and blurred shadows contrast nicely with the blue sky background, giving the user a sense of the freedom that PageNet's services promise to customers.

To keep the interface from appearing too static, rotating 3-D icons are used in the upper corner of each screen; internal display bars slide out of the frame and reveal more information to the user, or act as buttons linking to additional screens.

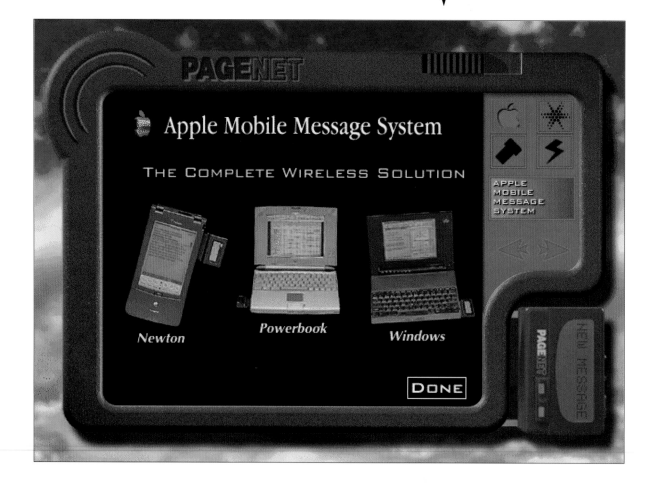

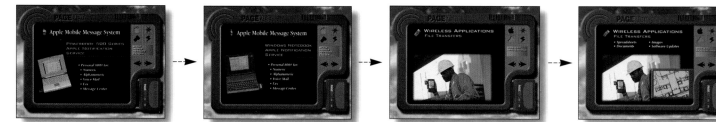

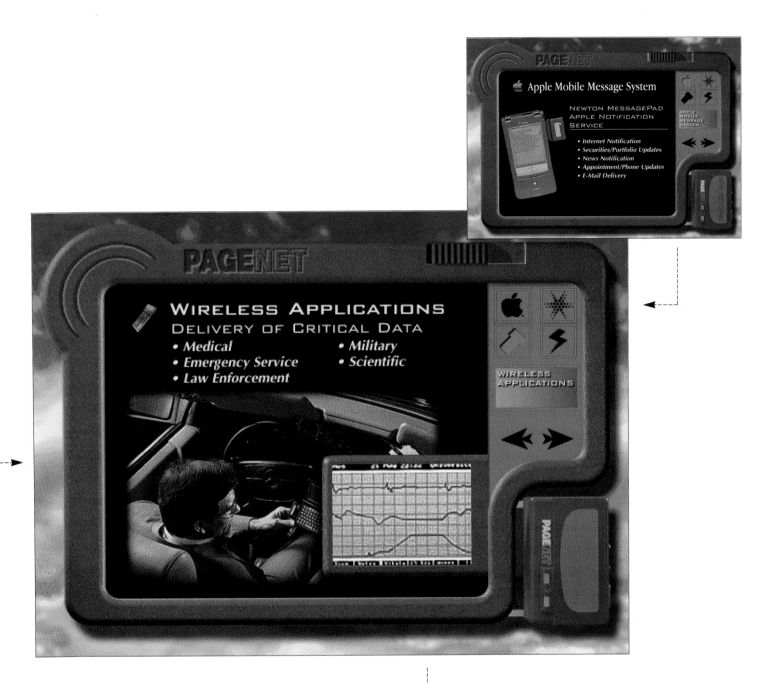

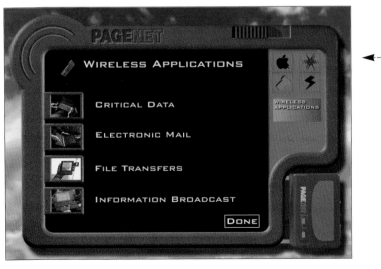

Project: **PageNet Trade Show Kiosk**
Client: **PageNet**
Design Firm: **Eagle River Interactive**
Designers: **Staff**
Authoring Program: **Macromedia Director**
Platform: **Mac**

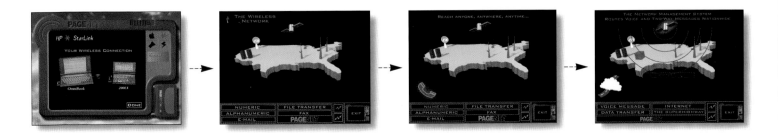

Directory

A.D.A.M. Software
1600 RiverEdge Parkway, Suite 800
Atlanta GA 30328
770.980.0888

ad•hoc Interactive, Inc.
221 Caledonia Street
Sausalito CA 94965
415.332.0180

Adobe Creative Services
411 1st Avenue South
Seattle WA 98104
206.470.7405

Alliance Interactive Media
3028 Esplanade, Suite B
Chico, CA 95973
916.893.4623

Aufuldish & Warinner
183 The Alameda
San Anselmo CA 94960
415.721.7921

The Becker Group
4108 Glen Garry Road East
Lakeland FL 33813
941.648.4606

Big Hand Entertainment Group, Inc.
4514 Travis Street, Suite 220
Dallas TX 75205
214.526.2888

Brøderbund
500 Redwood Blvd.
Novato CA 94948
415.382.4400

The Burdick Group
35 South Park
San Francisco CA 94107
415.957.1666

bYte a tree productions/Vizbyte
4041 Ridge Avenue, Building 17-105
Philadelphia PA 19129
215.848.9272

Canary Studios
600 Grand Avenue, Suite 307
Oakland CA 94610
510.893.1737

CBO Multimedia, A Division of
Cimarron, Bacon, O'Brien
812 N. Highland Avenue
Hollywood CA 90038
213.468.9580

David Ciske
9 South Wapella
Mt. Prospect IL 60056
708.392.7926

Clement Mok designs, Inc.
600 Townsend Street, Penthouse
San Francisco CA 94103
415.703.9900

Cooperative Media Group
170 Capp Street
San Francisco CA 94110
415.431.2250

CopperLeaf Design Studio
364 W. 1st Avenue
Columbus OH 43201
614.299.3864

Corbis
15395 S E 30th Place, Suite 300
Bellevue WA 98007
206.649.3363

The Design Office, Inc.
One Bridge Street, West Wing
Irvington NY 10533
914.591.5911

Digital Facades
1750 14th Street, Suite E
Santa Monica CA 90404
310.581.4100

Eagle River Interactive
1701 North Market Street, 4th Floor
Dallas TX 75202
214.720.8660

ECCO Design
89 Fifth Avenue
New York NY 10003
212.989.7373

Graffito/Active8
601 North Eutaw Street, Suite 704
Baltimore MD 21201
410.837.0070

Graphix Zone
42 Corporate Park, Suite 200
Irvine CA 92714
714.833.3838

HarperCollins Interactive
10 E. 53rd Street
New York NY 10022
212.207.7567

HotWired Ventures LLC
520 Third Street
San Francisco CA 94107
415.222.6340

Human Code, Inc.
1411 West Avenue, Suite 100
Austin TX 78701
512.477.5455

ICE (Integrated Communications
& Entertainment, Inc.)
489 Queen Street East
Toronto ONT M5A 1V1 Canada
416.868.6423

IDEO
1527 Stockton Street
San Francisco CA 94133
415.397.1236

Ignition
619 28th Avenue
San Francisco CA 94121
415.221.4226

imedia (Interactive Multimedia)
1112 Bryant Street, Suite 2 B
San Francisco CA 94103
415.626.8172

Imergy®
12 S. Main Street
Norwalk CT 06854
203.853.6200

Inscape
1933 Pontius Avenue
Los Angeles CA 90025
310.312.5705

Jive Turkey
28 Sanchez
San Francisco CA 91406
415.536.9526

Lightspeed Interactive
1235 Pear Avenue, Suite 103
Mountain View CA 94043

Lisa Marie Nielsen Design
1820 Outerway Drive, Suite 150
San Mateo CA 94404
415.965.3131

Macromedia
300 Townsend Street
San Francisco CA 94103
415.252.2000

Macworld Online
501 Second Street
San Francisco CA 94107
415.974.7396

Magnet Interactive Communications
3255 Grace Street, N W
Washington DC 20007
202.471.5800

Marcolina Design
1100 E. Hector Street, Suite 400
Conshohocken PA 19428
610.940.0680

Media Logic, Inc.
1520 Central Avenue
Albany NY 12205
518.456.3015

Media Magic
3 Echo Lane
Chico CA 95928
916.893.2708

MetaTools, Inc.
6303 Carpinteria Avenue
Carpinteria CA 93013
805.566.6200

Micro Interactive, Inc.
100 Fifth Avenue, 10th Floor
New York NY 10010
212.366.1391

Microsoft Corporation
1 Microsoft Way
Redmond WA 98052
206.936.4732

MNI Interactive, Inc.
501 2nd Street, Suite 350
San Francisco CA 94107
415.904.6222

Modem Media
228 Saugatuck
Westport CT 06528
293.341.5200

Thomas Müller
632 Park Avenue, # A
S. Pasadena CA 91030
818.403.1873

Multi-Mac-Media
507 D Pilgrim Court
Johnson City TN 37601
423.928.8856

Mya Kramer Design Group
604 Mission Street, 10th floor
San Francisco CA 94105
415.777.4433

Planet Design Company
605 Williamson Street
Madison WI 53703
608.256.0000

Planet Interactive
36 Drydock Avenue
Boston MA 02210
617.574.4800

Post Tool Design
245 South Van Ness, #201
San Francisco CA 94103
415.255.1094

Presto Studios
9888 Carroll Centre, #228
San Diego CA 92126
619.689.4895

Primo Angeli Inc.
590 Folson Street
San Francisco CA 94105
415.974.6100

Pulse Entertainment, Inc.
2902 A Colorado Avenue
Santa Monica CA 90404
310.264.5577

Red Dot Interactive
87 Stillman Street
San Francisco CA 94107
415.357.4877

Rhythm & Hues Studios, Inc.
5405 Jandy Place
Los Angeles CA 90066
310.448.7500

Ribit Productions, Inc.
14951 N. Dallas Parkway, Suite 220
Dallas TX 75240
214.239.8866

Shannon Roach
1206 33rd Street NW
Washington DC 20007
202.965.2027

Roecker Design Group
2401 15th Street, #350
Denver CO 80202
303.455.4800

SoftKey International
1 Atheneum Street
Cambridge MA 02142
617.494.5625

Southam Interactive
44 Frid Street
Hamilton Ont L8N 3G3 Canada
905.526.3395

StarPress
425 Market Street, 5th Floor
San Francisco CA 94105
415.778.3100

Sumeria, Inc.
329 Bryant Street, Suite 3D
San Francisco CA 94107
415.904.0800

Synstelien Design
1338 N. 120th Plaza, #9
Omaha NE 68154
402.491.3065

The Tuesday Group
178 S. Victory Blvd., Suite 208
Burbank CA 91502
818.567.3180

Visual Logic
724 Yorklyn Road, Suite 150
Hockessin DE 19707
302.234.5707

Ginny Westcott
1594 Creekside Drive
Petaluma CA 94954
707.762.0712

Roberta Lee Woods
200 Irene Court, #36
Belmont CA 94002
415.596.0639

WOW Sight+Sound
520 Broadway, Second Floor
New York NY 10012
212.941.4600

A

access time: amount of time it takes a CD-ROM drive (or other type of device) to locate and retrieve information, measured in milliseconds

attract loop animated loop that plays continuously until user input starts some other action, commonly used on kiosks to draw a user's attention

B

bandwidth data transmission capacity in bits of a computer or cable system; the amount of information that can flow through a given point at any given time

baud rate speed of a modem in bits per second

blue-screen a technique of filming a subject in front of a bright blue background that is evenly lit, so that when the video is digitized, the background can be easily masked out and a new one inserted

browser a program that allows a user to access information on the World Wide Web

buttons discrete graphical images that, when clicked upon or rolled over, trigger an action

byte a single unit of data (such as a letter or color), composed of 8 bits

C

CD-ROM (Compact Disc-Read Only Memory) an optical data storage medium that contains digital information and is read by a laser. Its name refers to the fact that the disc cannot be re-recorded, hence the term "Read Only."

CGI (common gateway interface) enables a Website visitor to convey data to the host computer, either in forms, where text is transferred, or as web mapping, where mouse click coordinates are transferred

CMYK cyan, magenta, yellow, black (kohl in German), the basic colors used in four-color printing

color depth the amount of information used to determine a color on a RGB computer screen. Color depth can be 24-bit (millions of colors), 16-bit (thousands of colors), 8-bit (256 colors), or 1-bit (black and white). The lower the color depth number, the smaller the file size of the image and the less realistic the color.

compression manipulating digital data to remove unnecessary or redundant information, in order to store more data with less memory

D

digitize convert information into digital form

F

floppy 3.5" portable magnetic storage diskette, holds 1.4 MB; inexpensive and nearly all personal computers can read this media

fps frames per second

G

GIF (Graphics Interchange Format) a file format for images developed by Compuserve. A universal format, it is readable by both Macintosh and PC machines

GUI graphical user interface, a computer interface utilizing windows, icons, and menus rather than text commands

H

home page the Web document displayed when you first access a site

hotspots areas onscreen that trigger an action when clicked upon or rolled over, usually these areas are not obvious to the user

hybrid CD-ROM a CD-ROM playable on both Macintosh and PC machines

hyperlink clickable or otherwise active text or objects that transport the user to another screen or Web page with related information

hypertext a method of signifying and storing written information that allows a user to jump from topic to topic in a number of linear ways and easily follow or create cross references between Web pages

I

interactive refers to a system over which the user has some control, that responds and changes in accordance with his or her actions

interface connection between two things so they can work together; method by which a user interacts with a computer

Internet a global computer network linked by telecommunications protocols. Originally a government network, it expanded to connect educational institutions and now comprises millions of commercial and private users

J

JPEG (Joint Photographic Expert Group) an image compression scheme that reduces the size of image files with slightly reduced image quality

K

kiosk a freestanding public terminal that an individual uses to access information

L

linear refers to a story, song, or film that moves straight through from beginning to end

M

megabyte (MB) approximately 1 million bytes

mixed-mode refers to compact discs that carry both audio and other types of data; especially refers to CDs that can be played in either CD-ROM drives or audio CD players

modem (modulator-demodulator) a device that allows computers to transfer data to each other across telephone lines

morphing the smooth transformation of one image into another through the use of sophisticated programs

MPEG (Moving Pictures Expert Group) a video file compression standard for both PC and Macintosh format

multimedia the fusion of audio, video, graphics, and text in an interactive system

N

non-linear refers to stories, songs or films, the sections of which can be viewed or heard in varying order, or which can have various endings depending on what has preceded

P

pixel short for picture elements, the smallest dot on a television or computer monitor that can be assigned a color value

R

RAM (random access memory) data storage that can be written or retrieved in a non-linear fashion

real-time data, graphics, or images processed in the present time, almost instantaneously

rendering adding surface and texture to a wire frame object. Rendered objects require long processing times and generally have large file sizes

repurpose to adapt content from one medium for use in another, i.e., revising printed material into a hypertext presentation

K

resolution measurement of image sharpness and clarity on a video display terminal, usually measured in number of pixels per square inch

RGB (Red, Green, Blue) type of display monitor used with computers; colors on a computer monitor are made up of red, green and blue, whereas colors in most print pieces are made up of CMYK (cyan, magenta, yellow and black) colors

rollover the act of rolling the cursor over a given element on the screen, resulting in another element to be displayed or a new action to begin

S

site a WWW location consisting of interlinked pages devoted to a specific topic

T

throughput the rate of data transmission at a given point, related to bandwidth

thumbnail small version of a large image, used for easy identification of pictures or actions

transfer rate the rate at which a CD-ROM drive can transfer information

U

URL (Uniform Resource Locator) standard method of identifying users or machines on the Internet. May be alphanumeric or only numeric.

V

virtual reality simulated world, usually computer-generated, which is immersive and interactive

voiceover narration accompanying and explaining onscreen action

W

wire frame a mesh or skeleton representation of a computer-generated model consisting of polygons and other simple geometric shapes. This is the first step in 3-D modeling, followed by rendering, which fills in the image to its finished form.

WWW (World Wide Web) graphical internet interface capable of supporting graphics within text, sound, animation and movies, as well as hyptertext linking from site to site

Resources

DESIGN SCHOOLS

American Center for Design
233 E. Ontario, Suite 500
Chicago IL 60611
312.787.2018

American Film Institute
2021 North Western Avenue
Los Angeles CA 90027
213.856.7600
http://www.afionline.org/home.html

Art Center College of Design
1700 Lida Street
Pasadena CA 91103
818.396.2200
http://www.artcenter.edu/

Cranbrook School of Design
http://oeonline.com/~crdesign/index
.html

Georgia Tech
Center for New Media
Atlanta GA 30332
404.894.2547

Rhode Island School of Design
2 College Street
Providence RI 02903

San Francisco State University
Multimedia Studies Program
415.338.1373
http://msp.sfsu.edu/

School of Communication Arts
612.721.5357

New York University
Tisch School of the Arts
Interactive Telecom. Program
212.998.1880

ONLINE MAGAZINES

CLICK
http://www.click.com

HotWired
http://www.hotwired.com

Interactive Week (online)
http://www.zdnet.com/intweek/

Multimedia Wire
http://www.mmwire.com/

Multimedia Online (Australia)
http://www.mm.com.au/amm/

Multimedia World
http://www.mmworld.com/

MAGAZINES

Applied Arts
885 Don Mills Road, Suite 324
Don Mills, Ontario
Canada M3C 1V9
416.510.0909

Design Graphics
2323 Randolph Avenue
Avene, NJ 07001
1.800.688.6247

HOW magazine
1507 Dana Avenue
Cincinnati OH 45207

Print
3200 Tower Oaks Blvd.
Rockville MD 20852

Publish Magazine
501 Second Street
San Francisco CA 94107
415.243.0600
http://www.publish.com

Communication Arts
P.O. Box 10300
410 Sherman Avenue
Palo Alto CA 94303
http://www.commarts.com/

CD-ROM Professional
18-1/2 Tremont St.
Cambridge MA 02139
617.492.0268

DV (Digital Video)
80 Elm St.
Peterborough NH 03458
603.924.0100

I.D. magazine
250 West 57th Street
New York NY 10107
212.956.0539

InterActivity
411 Borel Ave.
San Mateo CA 94402
415.655.4152

Multimedia Producer
153 Second St., #103
Los Altos CA 94022
415.917.8066

Multimedia World
501 Second St.
San Francisco CA 94107
415.281.8650
http://www.mmworld.com/

New Media
901 Mariners Island Blvd., #365
San Mateo CA 94404
415.573.5170

.net
30 Monmouth Street
Bath Avon BA1 2BW
England 01225.442244
http://www.futurenet.co.uk/net.html

the Net
1350 Old Bayshore Hwy, Suite 210
Burlingame CA 94010
415.696.1661

Wired
520 Third Street, Fourth Floor
San Francisco CA 94107
415.222.6200

ASSOCIATIONS

IICS
14657 S.W. Teal Blvd., #119
Beaverton OR 97007
503.579.4427

Interactive Multimedia Association
48 Maryland Ave., #202
Annapolis MD 21401
410.626.1380

Multimedia Development Group
2601 Mariposa St.
San Francisco CA 94110
415.553.2300

DEVELOPER'S LISTING

Corbis
A Passion for Art pp 14-15

Developer: James C. Gallant
Graphic Designers: Pei-Lin Nee,
Cecil Juanarena
Photographers: Dennis Brack,
Nicholas King, Edward Owen, Tess
Steinkolk, Gradon Wood
Sound Editors: Ella Brackett, Eileen
H. Monti, Curtis Wong
Multimedia Production: In House
Staff
Additional Programmers: Patrick
O'Donnell, Bill Radcliffe
Editor: Lorna Price
Segment Editor: Lisa Anderson
Segment Production: Ted Evans,
Vince Peddle
Writers: Karyn Esielonis, Mary
Tavener Holmes, Chiyo Ihiskawa,
Carol Ivory, Suzanne Kotz, Susan
L'Engle, Heather McPherson, Hal
Opperman, Christopher Riopelle,
Peter Selz, Martha Smith, Janis
Tomlinson, Carol Troyen
Assistant Producer: Eileen H. Monti
Macintosh Version Producer: Eileen
H. Monti
Macintosh Version Developer:
Jennifer Tobin

Pulse
Bad Mojo pp 18-19

Executive in Charge of Production:
Drew Huffman
Producer: Phill Simon
Writer: Vincent Carrella
Director of Engineering: Bill Zettler
Co-Producer: Alex Louie
Video Technical Director: Aaron
Strain
Original Score and Ambient Sound:
Peter Stone

Imergy
*Star Trek: The Next Generation
Interactive Technical Manual
pp 26-27*
Art, Animation and Lingo: Mike
Papaik, Brenda Garcia, Matthew
Mackey, Stephanie Triggiani, Andrew
Nichols, Ken Johnson

Inscape
The Dark Eye pp 28-29

Writer: Russell Lees
Project Director and Co-Producer:
David Nichols
Executive Producer: Michael Nash
Art Director: Rebekah Berhendt
3D Supervisor and Animator: Alex
Arko
Illustrators: Richard Downs, Bruce
Heavin, Roger Mikasa, Joe Strasser
3D Modelers: Stephen Brinca,
Edmund Kozin, Brian Speight, Dario
Antonioni (intern)
Designer: Linda Emme (*Annabel Lee*)
Illustrators: Polly Becker (Annabel
Lee), Richard Downs (Masque of the
Red Death)
Director of Photography: Jim
Aupperle

Costume Designer: Ariel Jones
Character Head Design: Bruce
Heavin
Puppet Makers: Andy Clement, Bill
Hunt, Darren Perks, Matt Singer

Sumeria
Exploring Ancient Cities pp 52-53

Editor in Chief: Jerry Borrell
Editor: Jonathan Piel
Production: Richard Sasso
Systems: Madlyn Keyes
Score: John Lewis
Video Editor: Paul McKerrow
Sound Engineer: Ken Gordon
Assistant Producer & Researcher:
Mark Wadnizak
Picture Editor: Jenny Loomis
Electronic Publishing: Martin Paul

IDEO
Interact p 56

Contributing Authors/Designers:
Lauralee Alben, Michael Arent,
Richard Bates, Durrell Bishop,
Thomas S. Bouchard, Daniel
Boyarski, Bruce Browne, Don Carr,
John Davison, Tom Erickson, Shelly
Evenson, Jim Faris, Charlie Hill,
Joost Kemink, Simon Kennedy, P.
Scott Makela, Richard Mander,
Aaron Marcus, Fiona McGettigan,
Pamela Mead, Hamish Muir, Dennis
Poon, John Rheinfrank, Rick E.
Robinson, Harry Saddler, Gitta
Salomon, Elizabeth Waymire, Yin Yin
Wong

CBO Multimedia, A Division of
Cimarron, Baker, O'Brien
Broken Arrow Website pp 140-141

Digital Artists: Robert Vega, Luke
Davis, Sabrina Soriano, Kaz
Matsume
Programmers: John Peterson
Production Manager: Amy Mattingly

ABOUT THE *IN YOUR FACE* CD-ROM

The *In Your Face* CD-ROM is an interactive resource showcasing the CD-ROM, floppy, online, and kiosk projects presented in the book. Also included are additional interactive projects.

Many of the "floppy" disk-based interactive projects premiered in the book are located on the CD-ROM as self-contained players. They can be accessed through the main contents screen or played directly from the "floppy" folder in the main IYF folder on the CD-ROM.

Two interfaces are available for navigating the *In Your Face* CD-ROM. The opening interface was designed by author Daniel Donnelly. David J. Link, Senior Art Director at Modem Media designed the second interface.

The thinking behind David's interface was to give the viewer a sense of navigating through a designer's sketchbook. Clicking on items in the sketch book take the user to other areas of the CD-ROM and offers interesting and humorous diversions.

BEFORE OPENING THE IYF CD-ROM

1. Be sure to turn off virtual memory in your control panel's "memory." When you do this you will need to restart your machine. This CD-ROM is compatible with RAM Doubler.

2. Set your monitor's color depth to 8-bit (256 colors). The IYF CD-ROM will not run properly otherwise.

IYF runs exclusively from the CD-ROM and does not install to your hard drive. For optimal playback of the floppy disk projects (located in the "floppy folder"), you can copy the projects to your hard drive.

TO PLAY THE IYF CD-ROM:

Macintosh:

1. Open the IYF folder on the CD-ROM.

2. If your computer is a Power Macintosh, double click on the "PPC" CD icon; for all other Macs (Quadras, II series, LC series, etc.) double-click on the "All Macs" CD icon. Quitting all other applications is recommended.

3. Double-click the CD icon and have fun. To bypass the opening, click the mouse button.

The "Help" button on the main contents page will show you how to navigate interface "one." Click on the "Interface two" button to navigate through the CD-ROM using an alternate interface.

Windows PC:

1. Choose "RUN" from the File menu. Type: (the letter of your CD drive) i.e. D:\IYF.EXE and then click "OK."

2. After the IYF CD-ROM starts you can bypass the opening by clicking the mouse button.

The "Help" button on the main contents page will show you how to navigate interface "one." Click on the "Interface two" button to navigate through the CD-ROM using an alternate interface.

To play specific floppy disk projects located in the "floppyf" folder: Choose "RUN" from the File menu and type:

D:\IYF\FLOPPYF\filename.exe or locate the "floppyf" folder and double-click the desired project name to begin.

PROJECTS FEATURED ON THE IN YOUR FACE CD-ROM

Macintosh:

1. @Type.New
2. Angus IPK
3. Becker Portfolio
4. David Ciske
5. Diskfolio 2
6. Ecco Cricket
7. Eight
8. fontBoy
9. J.W. Fry
10. Gravity
11. imedia Studio Tour
12. Joe Mack's Job Seek
13. Lollapalooza IPK
14. Mary Chapin Carpenter IPK
15. MOFO Reference Tool
16. Ribit
17. Selected Notes 2 ZeitGuys
18. Soul Coughing
19. Surreal Resume
20. Synstelien Portfolio
21. WEPI Interactive Business Card
22. Ginny Westcott
23. Roberta Woods Portfolios 1 & 2
24. WOW Portfolios:
 - Frank Micelotta
 - Michel Tcherevkoff
 - Joyce Tenneson
25. ZeitMovie
26. Zion Canyon: Treasure of the Gods

Windows PC:

1. angus.exe
2. fry.exe *
3. imedia.exe
4. mofo_ref.exe
5. type.exe *
6. wblol.exe *
7. westcott.exe *
7. woods.exe
8. zion.exe *

* Indicates that the project can be accessed directly through the project screens on the *In Your Face* CD-ROM.